WATERCOLOR PAINTING
at Home

Easy-to-follow painting projects inspired by the
comforts of home and the colors of the garden

BLEY HACK

Walter Foster

Brimming with creative inspiration, how-to projects, and useful information to enrich your everyday life, quarto.com is a favorite destination for those pursuing their interests and passions.

© 2022 Quarto Publishing Group USA Inc.
Text and artwork © 2022 Bley Hack

First published in 2022 by Walter Foster Publishing, an imprint of The Quarto Group.
100 Cummings Center, Suite 265D, Beverly, MA 01915, USA.
T (978) 282-9590 **F** (978) 283-2742 **www.quarto.com** • **www.walterfoster.com**

Walter Foster Publishing titles are also available at discount for retail, wholesale, promotional, and bulk purchase. For details, contact the Special Sales Manager by email at specialsales@quarto.com or by mail at The Quarto Group, Attn: Special Sales Manager, 100 Cummings Center, Suite 265D, Beverly, MA 01915, USA.

ISBN: 978-1-60058-942-3

Digital edition published in 2022
eISBN: 978-1-60058-943-0

Proofreading by Savannah Frierson, Tessera Editorial

Printed in China
10 9 8 7 6 5 4 3 2 1

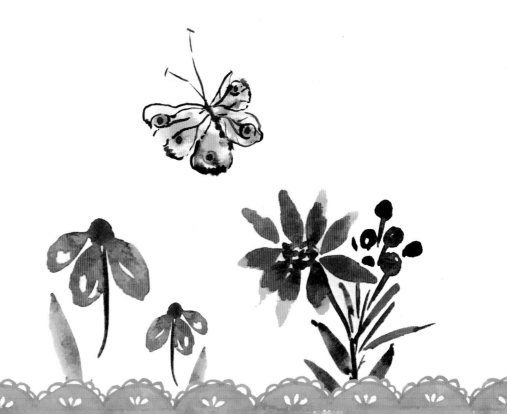

Table of Contents

Introduction

"Ah! There is nothing like staying at home for real comfort."
- Jane Austen

And, I would add, nothing like staying at home for real inspiration!

I have always loved being at home. When my husband and I bought a farm in the country four years ago, it confirmed in my mind what I had always suspected: that my homebody-ness was deeply integral to me, and that home, the idea and the reality, is one of the chief inspirations in my life.

No one can argue that our immediate environments aren't very influential; witness our society's obsession with home décor. But when one spends so much time at home, home must take on a more utilitarian aspect, able to facilitate our interests and pursuits, duties, and pleasures. One of the main ways my home facilitates my pursuits and pleasures is by providing a location and inspiration for my art.

Now I have the pleasure of inviting you into my home, to show you the ways it inspires me and how you can translate these ideas to find inspiration in your own home. Imagine you are coming into my house, to the kitchen table where we can sit together, spread out our supplies, and paint. I will show you how to look around at your surroundings and generate ideas. One point I would like to emphasize is that the subject matter does not necessarily have to elicit excitement to make for an exciting painting. If you look at historical and contemporary artists, many of them can take the most mundane subjects and turn them into brilliant work. While our endeavors may not live on in history, they can inspire us to use the things at hand as fodder for our painting practice.

Let's get started!

Finding Inspiration

*"It doesn't matter where I go so long as I break
my routine and see new things."*
- Vera Neumann

I think the above sentiment by iconic American designer Vera Neumann perfectly sums up how to find inspiration: seeing new things. Seeing new things does not necessarily mean going someplace new, however. Sometimes you must learn to see familiar things in a new way. Here are some ways that I do this around my home.

BOOKS

If there is one thing that has always enlivened the world for me, it's books. As a teen, I would check out stacks of books from the library and read about and study pictures of historic homes and interior design. This helped build what I would call a visual library of images and ideas to draw from. Books on almost any subject matter may apply; even now, a quote, word, or picture in my child's schoolbook can send me in an inspired new direction.

ARMCHAIR TRAVEL

We may be tied to home, but that doesn't mean that we can't experience new pictures and places. I have recently revisited some of my favorite travel videos from the 1990s, and they still hold a charm. Books, magazines, and videos showing different cultures are some of the best sources of imagery that can spark a new idea.

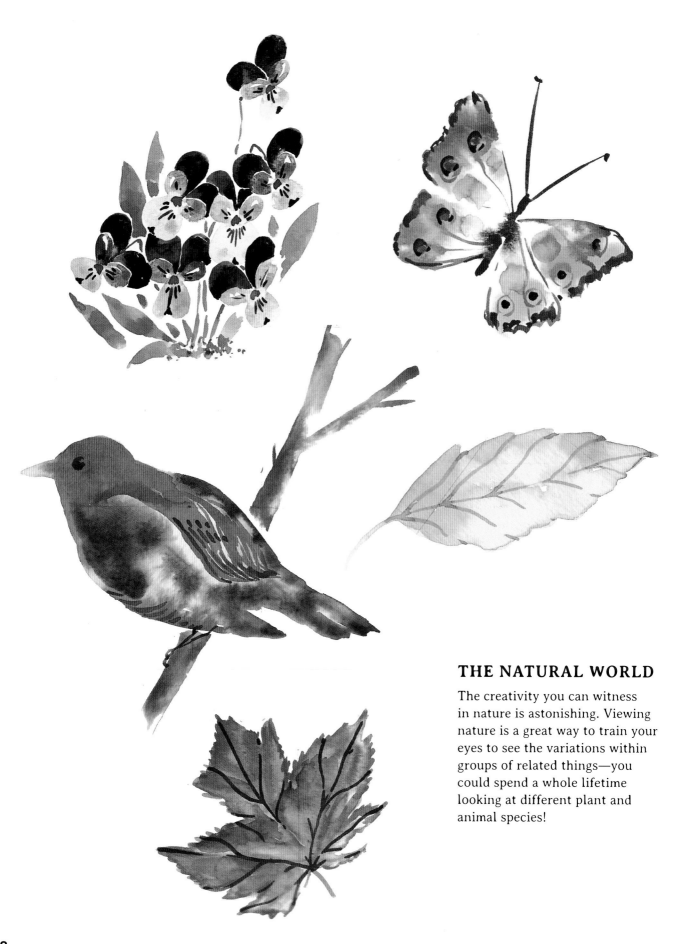

THE NATURAL WORLD

The creativity you can witness in nature is astonishing. Viewing nature is a great way to train your eyes to see the variations within groups of related things—you could spend a whole lifetime looking at different plant and animal species!

COLLECTIONS

Our homes tend to be collections of items, whether we have what might be considered a formal "collection" of something or not. The home itself—with its furnishings and accessories, the items we've chosen to surround ourselves with—can lend itself as subject matter. The main reason I love to paint still lifes, with various bits and pieces of crockery I've collected, is that I already have a love for the crockery itself. To get to use it in another way is an extra joy.

Tools & Materials

"Paints and brushes are good servants, but bad masters."
- William Collingwood

Watercolor is a beautiful medium because it can be as simple or elaborate as you want it to be. With minimal materials, you can explore and complete all the projects in this book. Sometimes it can even be helpful to limit your materials as you begin. This forces you to become familiar with how they work together and can provide some natural limits on your choices to avoid decision fatigue!

The following supplies are the most essential.

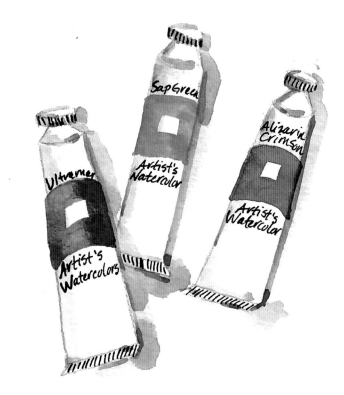

PAINTS

Here you have a choice between watercolors in a pan or watercolors in a tube. Watercolors in a pan often have a palette (the mixing surface) built into them. If you choose watercolors in tubes, you will also need a separate palette.

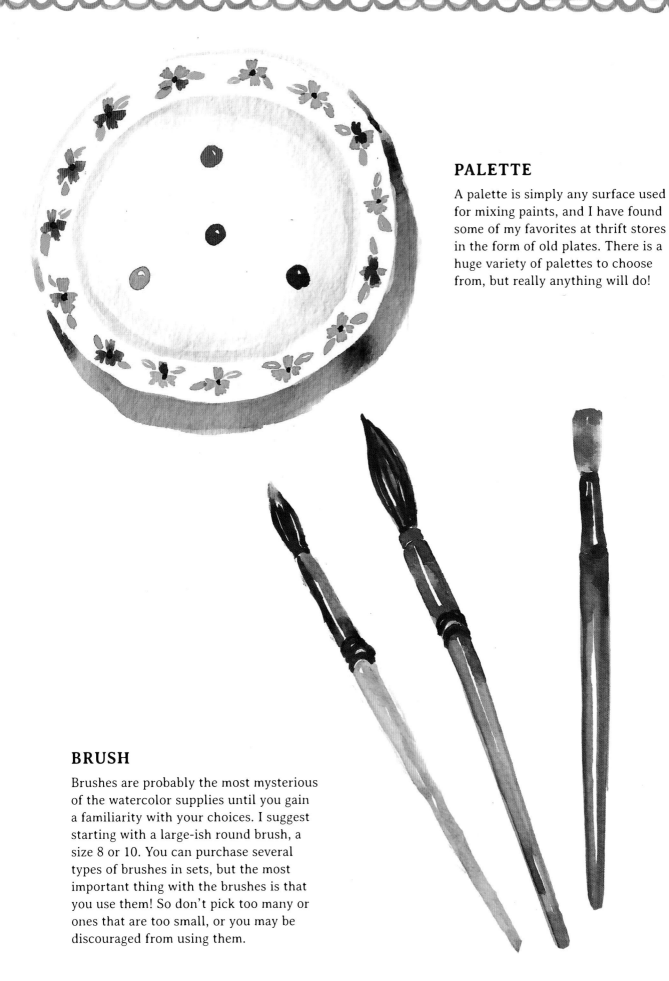

PALETTE

A palette is simply any surface used for mixing paints, and I have found some of my favorites at thrift stores in the form of old plates. There is a huge variety of palettes to choose from, but really anything will do!

BRUSH

Brushes are probably the most mysterious of the watercolor supplies until you gain a familiarity with your choices. I suggest starting with a large-ish round brush, a size 8 or 10. You can purchase several types of brushes in sets, but the most important thing with the brushes is that you use them! So don't pick too many or ones that are too small, or you may be discouraged from using them.

PAPER

Another essential item, paper is the surface to paint on. I suggest buying paper that is not so expensive that you are hesitant to use it. The more you practice, the better, so buy paper that is economical enough to use.
I favor Canson® XL® watercolor paper in a cold-pressed weight.

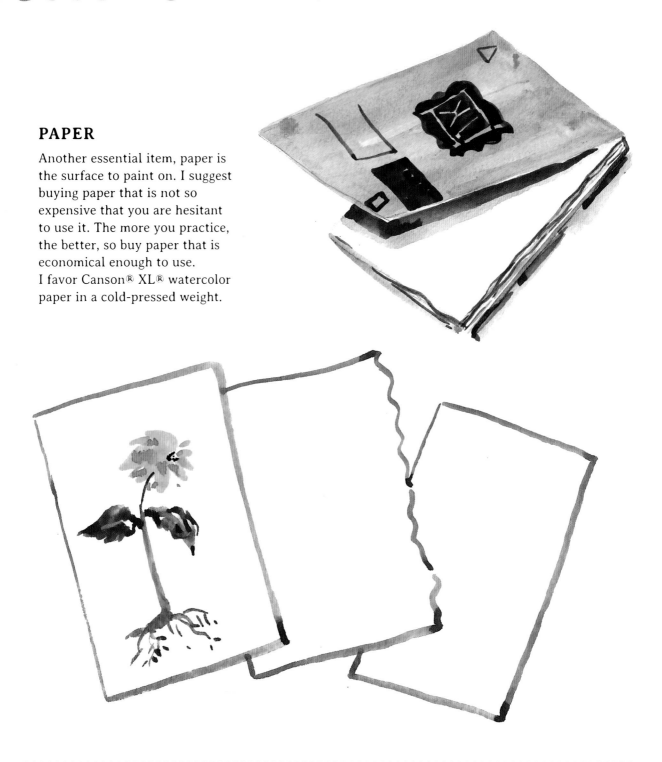

Paper Weights

The three different weights of paper are hot-pressed, which has a very smooth surface; cold-pressed, which is a medium-textured surface with a slight tooth; and rough, which is a heavily textured paper surface. It can be fun to experiment with different surfaces once you gain a bit of experience.

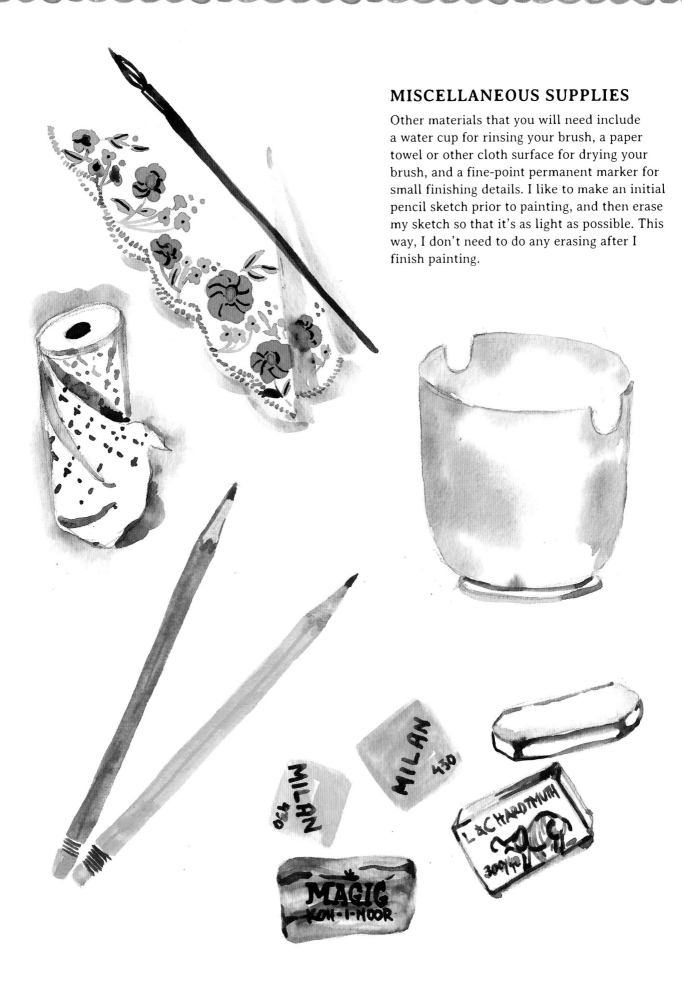

MISCELLANEOUS SUPPLIES

Other materials that you will need include a water cup for rinsing your brush, a paper towel or other cloth surface for drying your brush, and a fine-point permanent marker for small finishing details. I like to make an initial pencil sketch prior to painting, and then erase my sketch so that it's as light as possible. This way, I don't need to do any erasing after I finish painting.

Painting Techniques

A feature of watercolor, spontaneity is what makes this medium exciting!
But there are also a number of techniques that you can practice that will hone
your painting skills and harness the freedom of this beautiful paint.

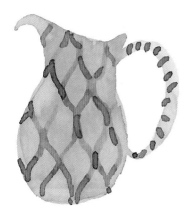

FLAT WASH

A uniform application of paint color, a flat wash is useful as a first layer for objects, and as a background color.

GRADIENT WASH

A gradient wash is made by concentrating more pigment in one area of a wash than another. This is a great technique to show the form of an object, or as a sky application.

GLAZING

Glazing occurs when you apply one color to your painting and allow it to dry before layering another color on top. Use glazing to darken certain areas of an object or to show overlap.

DRYBRUSHING

Just as it sounds, the drybrushing technique employs the natural texture of the paintbrush to create a staggered-looking "dry" stroke. It is great for conveying texture, especially in animal fur and landscape features, like grass.

BLEEDING

Another aptly named technique, bleeding allows pigments to blend naturally. This can be a difficult technique for beginners to embrace sometimes, but once you get seduced by the beautiful accidents that happen in this technique, you will be convinced. Simply place shapes of different colors with two edges touching each other while wet and let the magic happen.

WHITE HIGHLIGHTS

One tricky aspect of watercolor is that there is no white paint; you must rely on the white of your paper for the brightest highlights. One way to approach this is to leave small areas of shape unpainted, thus preserving the white. You can use this highlight to also imply form by curving the shape of the highlight to mimic the form. Highlights are important in creating a pleasing painting; it is one more area for the light to bounce from and attract the eye of the viewer.

WET-INTO-WET

One of my favorite techniques, wet-into-wet refers to wetting the paper and then dropping in wet paint. This technique is excellent for creating animals: Simply wet the silhouette of the animal fully with plain water, and then drop in your colors and allow them to blend naturally as they dry. You will often end up with darker, shadowed areas and white areas as highlights.

WAYS TO USE YOUR BRUSH

You can practice these strokes to improve your skills with a paintbrush.

FINE OR OUTLINE STROKE

Use just the tip of the brush and move your strokes quickly for fine lines.

Hold the brush like this:

Use this stroke for:

Small marks around centers

Thin vein details

Outlining a shape Delicate foliage

THICK LINE STROKE

Push the brush down all the way and pull the line out. Vary the pressure at beginning, end, or middle for different line widths.

Hold the brush like this:

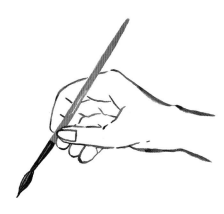

Use this stroke for:

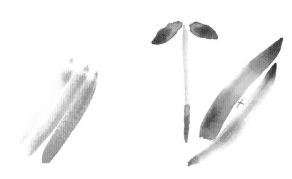

Fatter, longer lines Outlining shapes

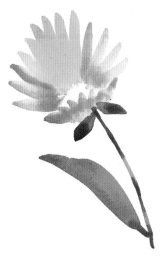

Thick line strokes around the center create a flower head.

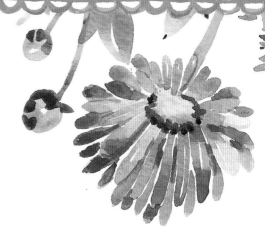

STAMP & PULL STROKE

"Stamp" brush to paper and pull to create a shape. Vary the direction and pressure in which you pull for different shapes.

Hold the brush like this:

Or hold the brush like this:

Use this stroke for:

A stacked stamp:

Stamp the brush in a series to create the overall shape of leaf or flower.

These petals are tapered around the outer edge.

The point of the brush faces the tapered end of a petal.

These petals are tapered toward the center.

Design

Now let's discuss some considerations to keep in mind when designing a painting. These are: composition, balance, and variety.

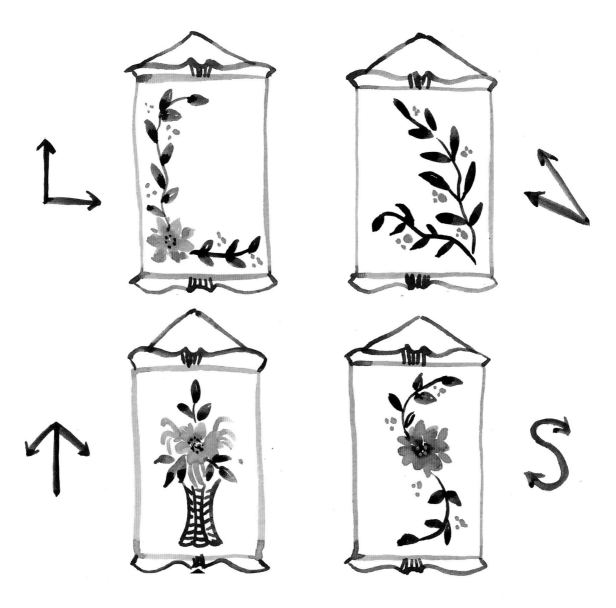

COMPOSITION

This refers to the placement of objects or shapes on the paper. Here are a few examples of differently shaped compositions.

You can observe how the overall shape of the pieces fits together to lead your eye on a particular path through the picture. That is the essential thing to remember about composition. As the artist, you are leading your viewer through the picture. A great way to learn composition is to look at historical artists; see if you can identify an overall shape or design that they used to get you to look at the focal point of the picture. Use the four compositional arrangements above as you practice.

BALANCE

Balance refers to what the viewer interprets to be pleasing to the eye. This is, of course, subjective; however, there are a few rules of thumb to use. Let's consider this painting as we look at the different "rules."

First, an odd number of shapes is usually pleasing to the eye. Second, employing the reflection of color from one area of your painting to another can lend balance. Third, the size of your objects is important; the composition will not be as pleasing if all objects are the same size or if there is too great of a contrast between sizes.

VARIETY

You should aim for variety in your painting in these areas: color, shape, size, and number. Look at this painting and notice how flowers are repeated in size and color to achieve balance, but how the different flowers vary by size and shape to achieve variety.

Color Theory & Color Palettes

Color is one of the most exciting aspects of watercolor painting; who can resist the appeal of all those gorgeous hues of pigment? Knowing just a bit about the different hues and their relationships to each other can help broaden your palette, even if you only start with three colors. The three primary colors are yellow, red, and blue.

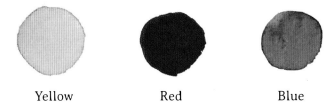

Yellow Red Blue

Mixing these three in different combinations will broaden your palette to twelve colors. Here is how you do it:

First, mix yellow and red to make orange. Then mix red and blue to make purple. Finally, mix blue and yellow to make green. These are called secondary colors; observe how they are placed around the color wheel below.

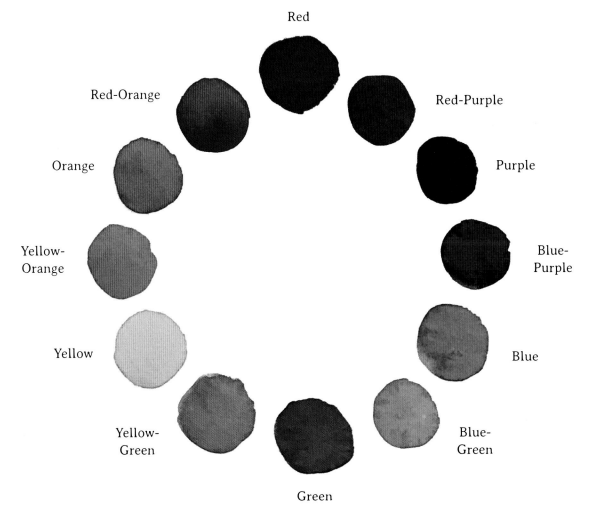

You can now mix another set of colors, called tertiary colors, to fit between the primary and secondary colors.

Mix orange with red to make red-orange. Mix yellow with orange to make yellow-orange.

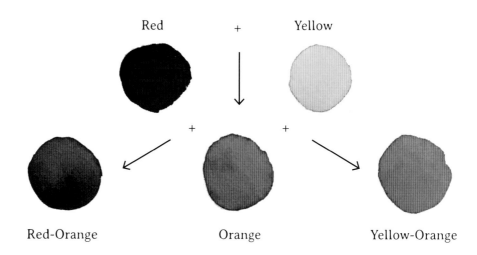

Red + Yellow

+ +

Red-Orange Orange Yellow-Orange

Mix green with yellow to make yellow-green. Mix blue with green to make blue-green.

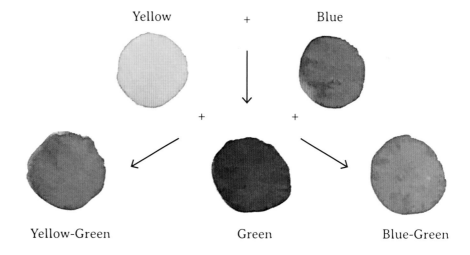

Yellow + Blue

+ +

Yellow-Green Green Blue-Green

Mix purple with red to make red-purple. Mix blue with purple to make blue-purple.

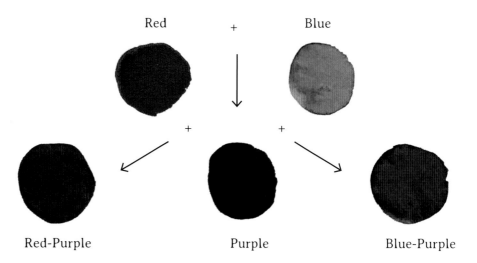

Red + Blue

+ +

Red-Purple Purple Blue-Purple

Practice mixing these colors to learn the nuances of your various pigments. One fun exercise I have my workshop students complete is a color wheel wreath. Once you are familiar with mixing twelve shades from the three primaries, you can use the color wheel on page 20 as a reference and paint a wreath of flowers, using one flower for each color.

COLOR COMBINATIONS

A simple way to make a flower is by "stamping," using the natural shape of the brush. Several of these petals placed together will create a flower.

Once you've painted your flowers, practice mixing neutral colors for some leaves between the flowers. The easiest way to mix a neutral color is to use two shades directly across from each other on the color wheel.

Here are a few suggestions: red and green, blue and orange, or yellow and purple.

As you can see, each of these wreaths turns out unique, and they all look fabulous when put together! You can continue to practice these color exercises by substituting different reds for the primary red, or you could also use pink. Try a warm yellow-brown pigment like yellow ochre for the yellow. Blue can easily be substituted with a more purple pigment to mix many lovely grays. These three wreaths were painted using different combinations of primary colors.

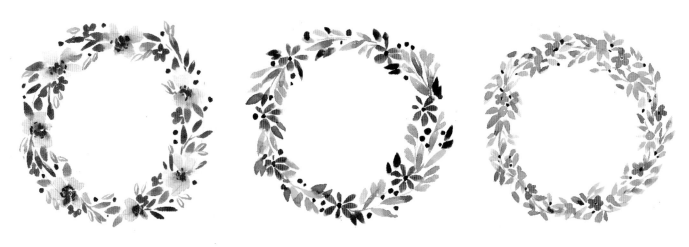

Experiment and enjoy using the pretty new colors you mix!

Fruit Bowl Still Life

One of the best places to start painting is with easy forms and vibrant colors. The fruit bowl on my kitchen counter sparked the idea, and then I thought about our local fruits and flowers and developed the idea from there. I encourage you to think about what produce and flowers are native to your area and build your fruit bowl around those, using the process I show here.

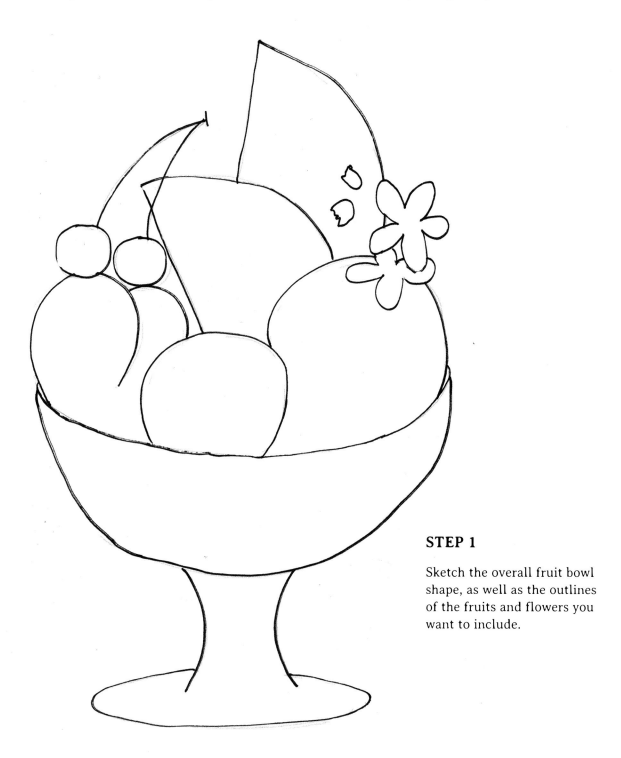

STEP 1

Sketch the overall fruit bowl shape, as well as the outlines of the fruits and flowers you want to include.

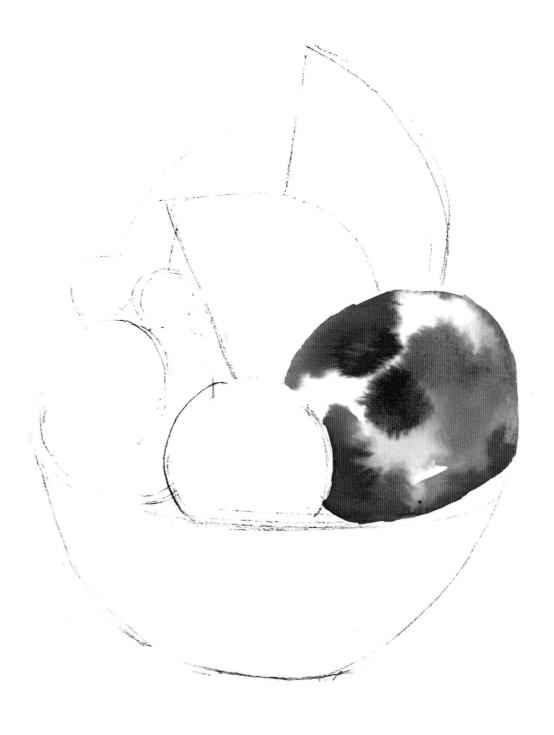

STEP 2

Using the wet-into-wet painting technique (page 15), wet the shape of the apple with clear water. With bright reds and oranges, drop in the paint color to imply the form of the apple. Leave some white areas where the paint doesn't bleed for highlights.

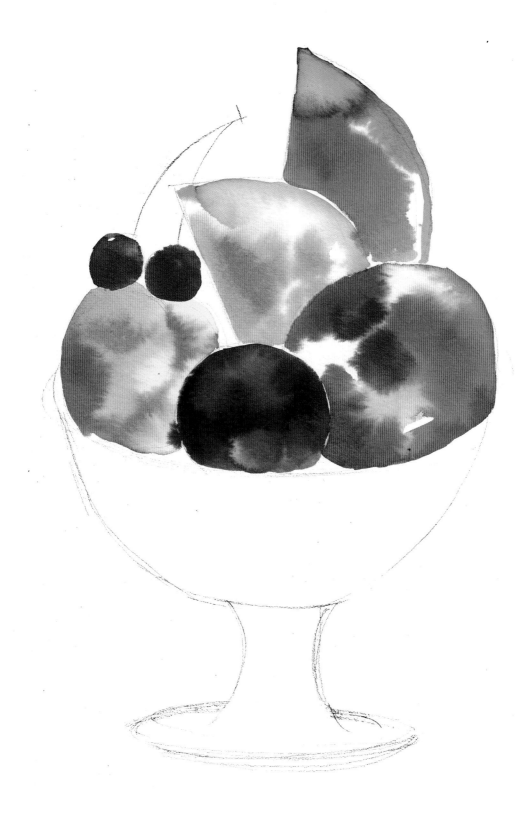

STEP 3

Continuing with this method, wet and paint other fruits, such as a plum, a peach, cherries, a cantaloupe, or a watermelon. A little garnish of apple blossoms and wild violets completes these fruits and flowers. Be sure to wet each fruit without touching the other fruits; wherever wet touches wet, it will bleed. You can manage this by painting fruits on opposite sides of the bowl. Once a fruit is fully dry, you can wet the adjacent fruit. Enjoy the process of letting the colors bleed into each other, and try to vary the shades you use in each fruit—a couple different oranges for the peach, for example.

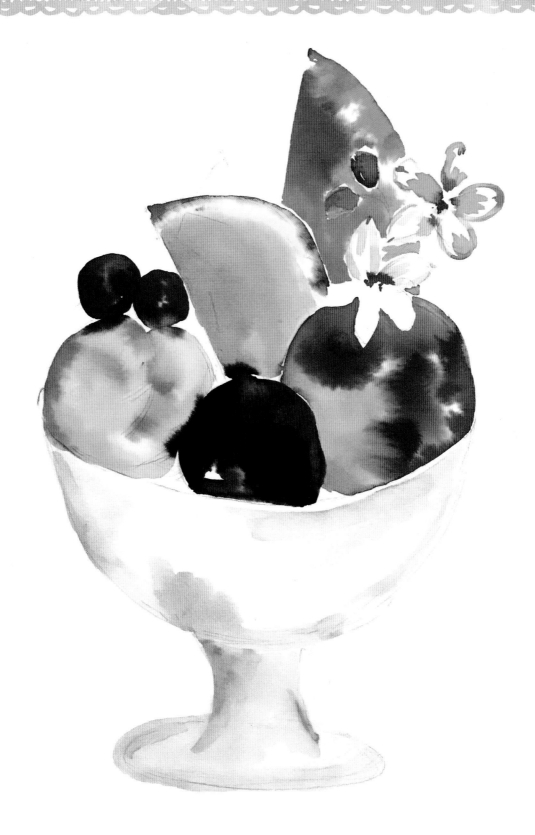

STEP 4

Now add some shadows to the white-footed fruit bowl. The shadows will give the bowl form and set the stage for the decorative details to be added later. Convey that the bowl is white by leaving some large white areas near the middle of the bowl. Use a gradient wash technique (page 14) to make the edges of the bowl darker with shadowed areas, which fade as you get closer to the middle. Also, add some color to the apple blossom flowers.

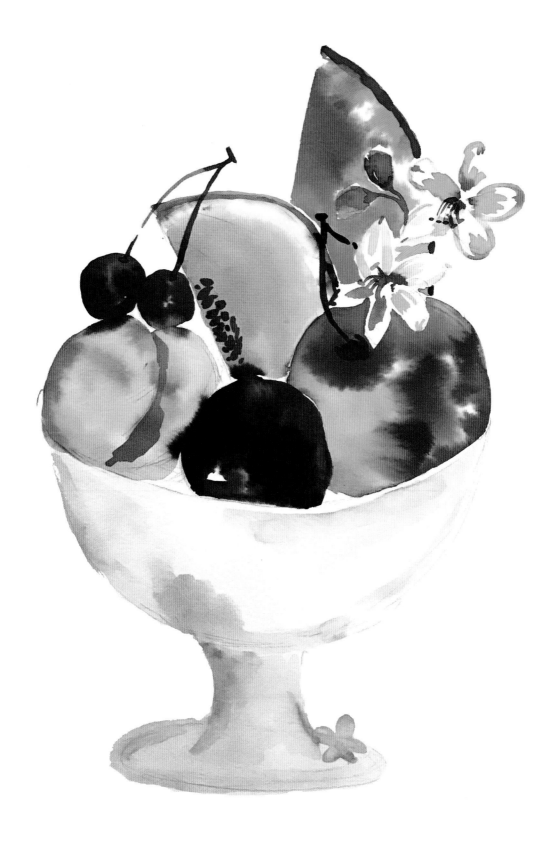

STEP 5

It's time to begin adding the finishing touches, including seeds on the cantaloupe and stems on the cherries and apple. Darken any areas on the fruits that look like they need it.

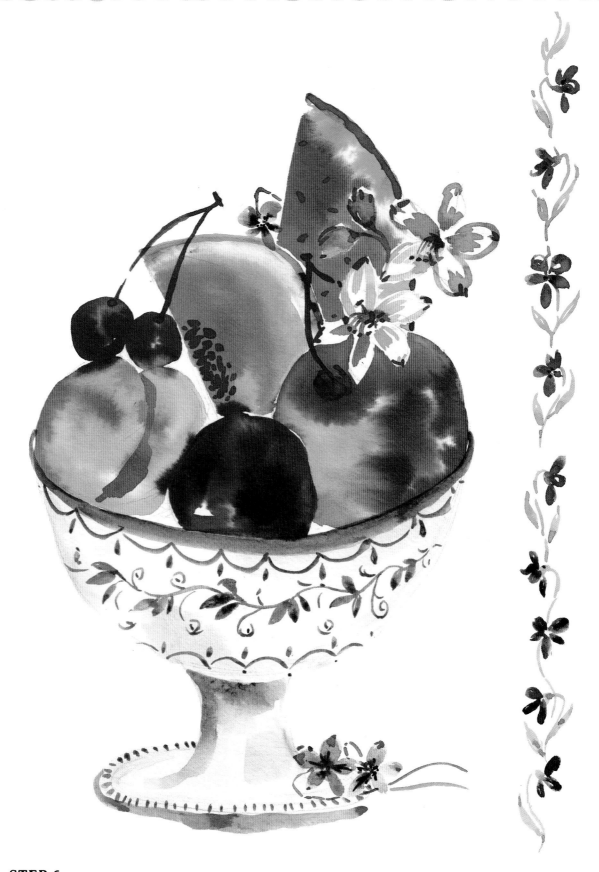

STEP 6

Finally, add a pretty pattern to the fruit bowl. I've done a simple blue-and-white motif, but you can be inspired by a piece of your own kitchen crockery. Add some seeds to the watermelon and a few little violet flowers. I felt like my fruit bowl needed some additional decoration, so I've added the border of wild violets on the edge.

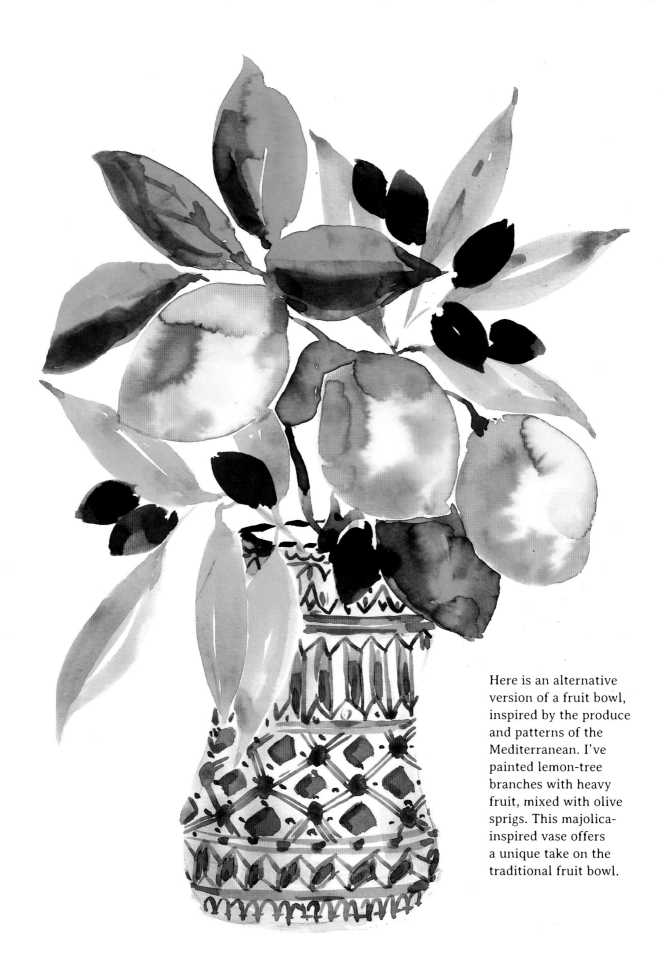

Here is an alternative version of a fruit bowl, inspired by the produce and patterns of the Mediterranean. I've painted lemon-tree branches with heavy fruit, mixed with olive sprigs. This majolica-inspired vase offers a unique take on the traditional fruit bowl.

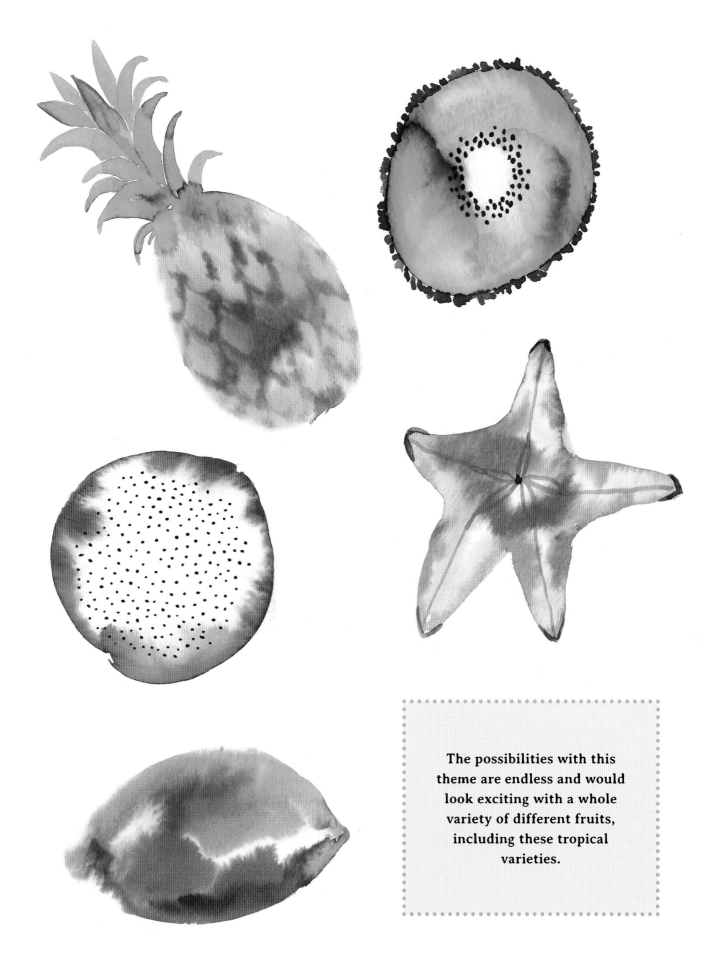

The possibilities with this theme are endless and would look exciting with a whole variety of different fruits, including these tropical varieties.

Painting Supplies

I love to paint my painting supplies because with those vibrant colors, you just can't go wrong! This project is a celebration of the pigments of your palette and how even simple tools can make an interesting piece of art.

STEP 1

Begin by sketching the outlines of your supplies. An easy compositional trick to improve your picture is to overlap various objects. This helps show their arrangement in space and implies that some objects are closer than others to the viewer.

STEP 2

For this project, try to keep your colors minimal, except when you are representing the paint colors on the palette. Too many colors everywhere and the picture will lack harmony. The eye needs a place to rest; provide that by keeping most sections simple in color.

Begin by placing some shadows around your supplies and defining the forms of the objects.

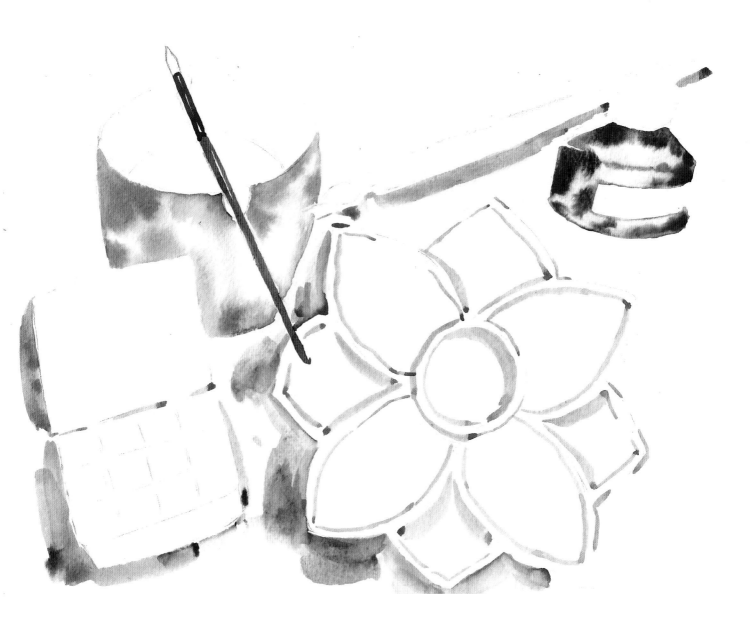

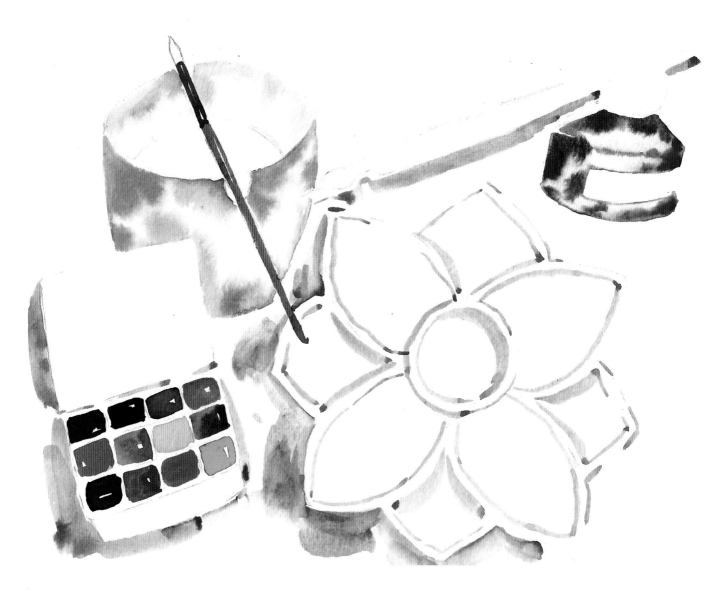

STEP 3

Add the colors on the small paint palette box. Remember which colors you use so that you can use them again when painting the flower palette. Also add the inside of the water cup, perhaps using a wet-into-wet technique to keep the colors light.

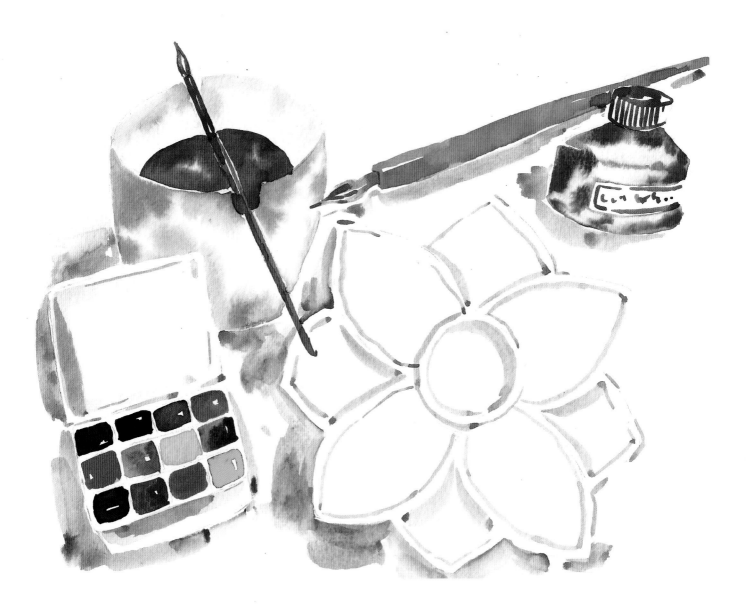

STEP 4

Continue to flesh out the painting by adding color to the dip pen and paint water. Remember that in watercolor you can always add, but you cannot take away, so leave some extra little white highlights in your objects. You can always paint over them if you wish later, but you can never add them back in.

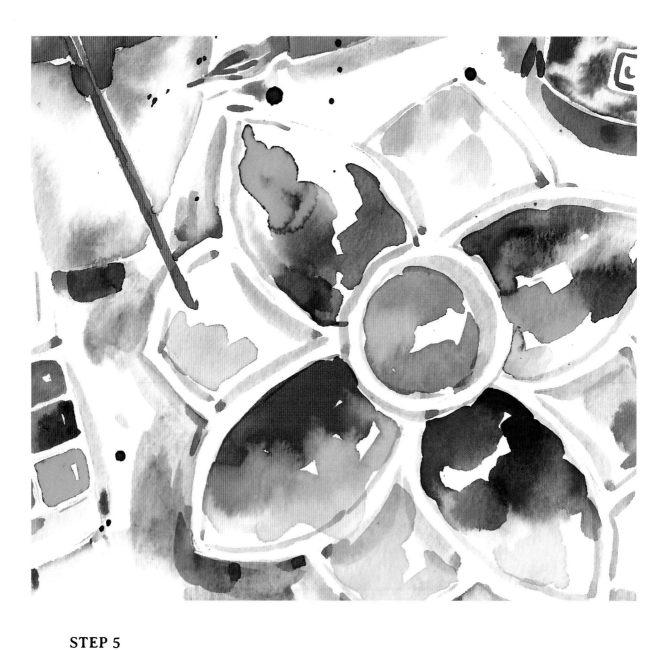

STEP 5

Finally, add details to the shadows and get some messy colors on your palette!

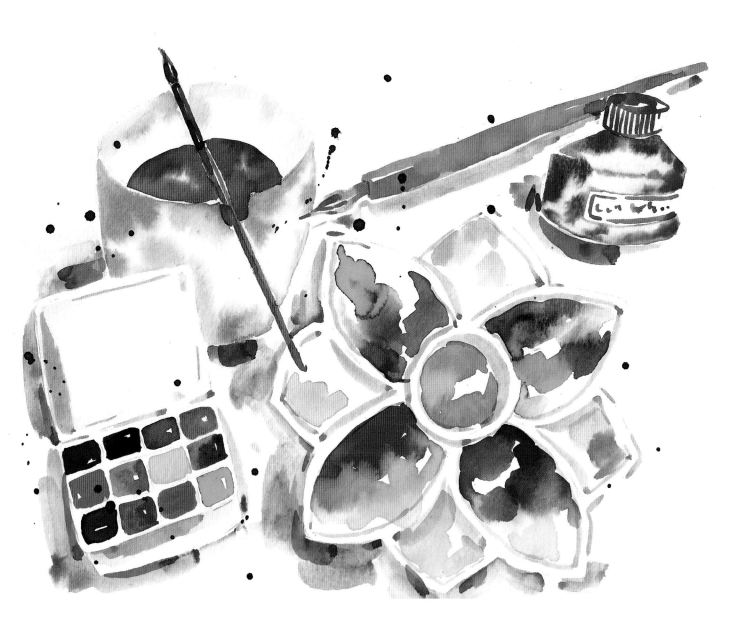

To give a final flourish and to keep the piece from becoming too "precious," you can add some random paint splatters.

Pets—Real or Imagined

One of the most fun subjects to paint at home is the creatures who keep us company. Pets are fun to paint because they present interesting shapes and colors and the challenges of conveying texture. I use this simple formula to paint animals.

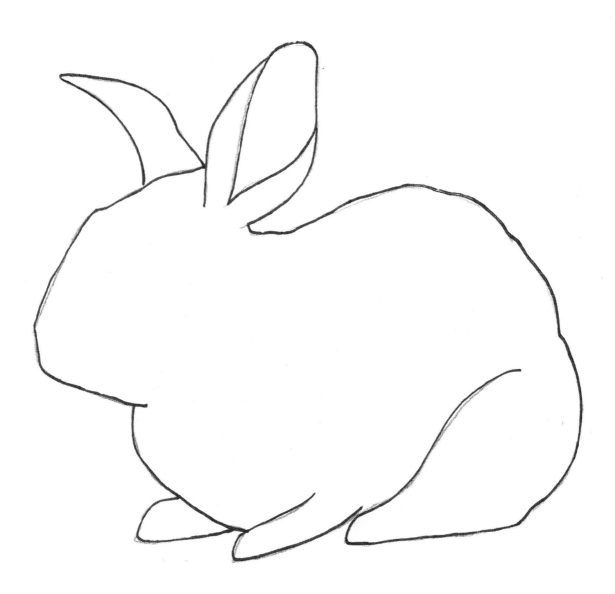

STEP 1

First, sketch the silhouette with pencil. A great way to capture the characteristic look of an animal is to get its overall shape, or silhouette, correct. If your pet friend won't hold still long enough for you to capture his outline, search online for images of an animal that you can sketch.

STEP 2

Use the wet-into-wet painting technique to give an illusion of texture.

Wet the whole shape of the animal, and then strategically drop in paint and let it bleed. I like to drop the paint around the edges first, and then in the shadowed areas along the legs and bellies. Varying your overall paint color slightly will provide additional interest. Make sure to paint sparsely and leave some areas white. Allow it to dry like this for the best results.

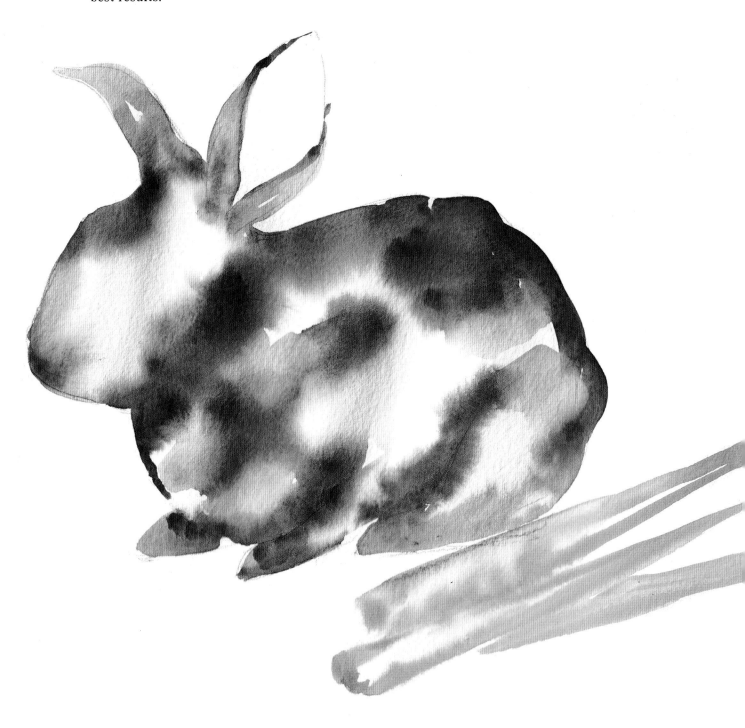

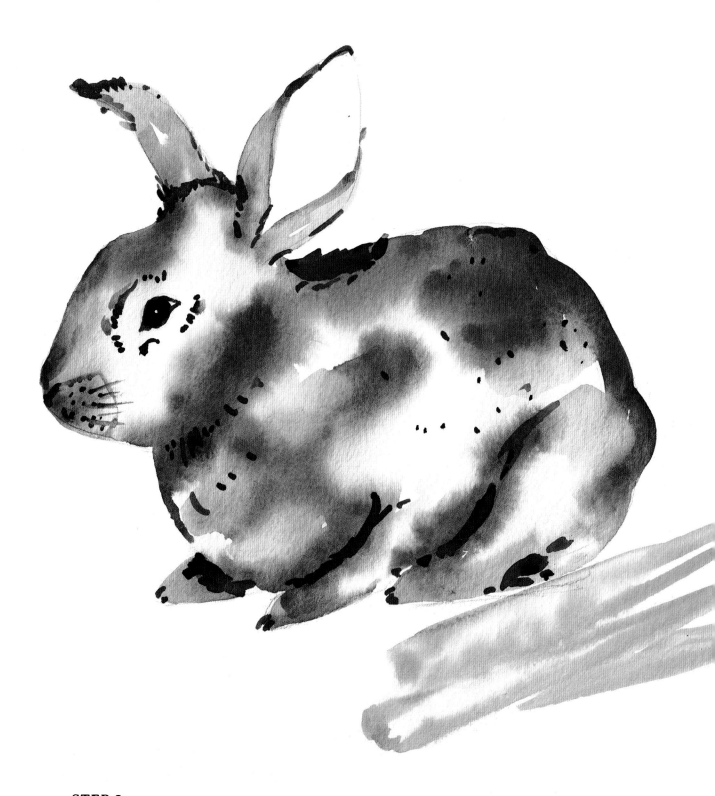

STEP 3

Really observe where the eyes are in relation to the rest of the animal's features and what size and shape they are. If you need more control than a paintbrush can lend, use a fine-point permanent marker. To avoid mistakes, you can sketch the placement in pencil first.

Adding fur markings or patterns is also helpful in establishing the believability of the animal. Just remember that a little goes a long way.

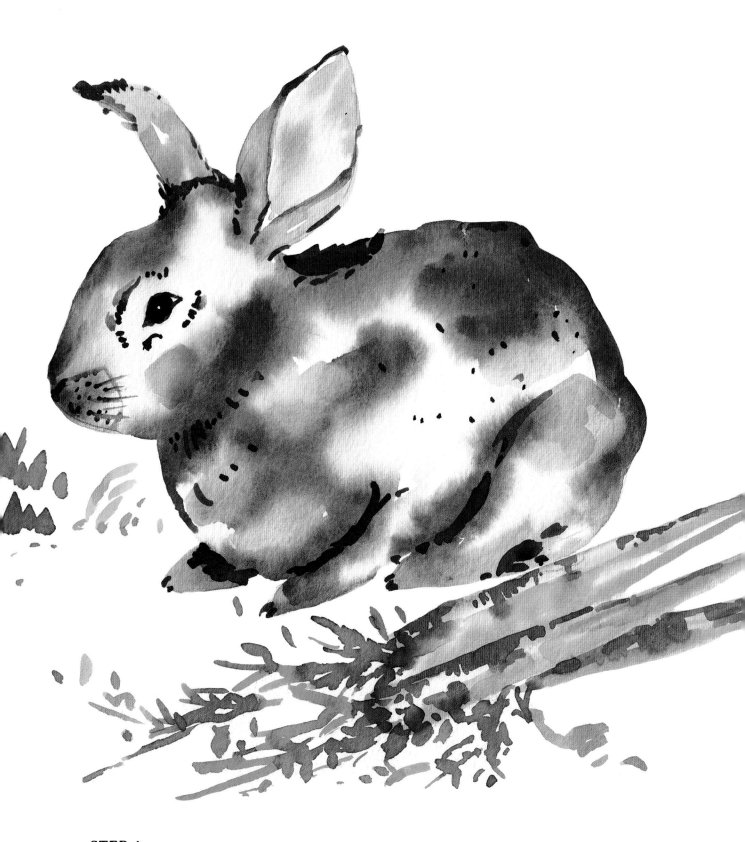

STEP 4

Now add some fun accessories. Ideas here are endless: what does your pet eat, what does he play with, where does he play? Have some fun with this!

Color Tips

When you're painting animals, you often need to mix a number of different neutral colors, such as black, browns, and grays. To make these colors as vibrant as the rest of your palette, use your color theory knowledge (pages 20-23). For a dark black, mix a brown with a blue.

Because these are complementary colors (colors across from each other on the color wheel; see page 20), they mix to form a neutral. Play around with different proportions of these two colors to skew your neutral more brown or more black/gray.

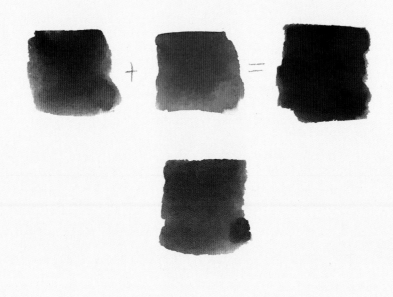

TAKE IT A STEP FURTHER

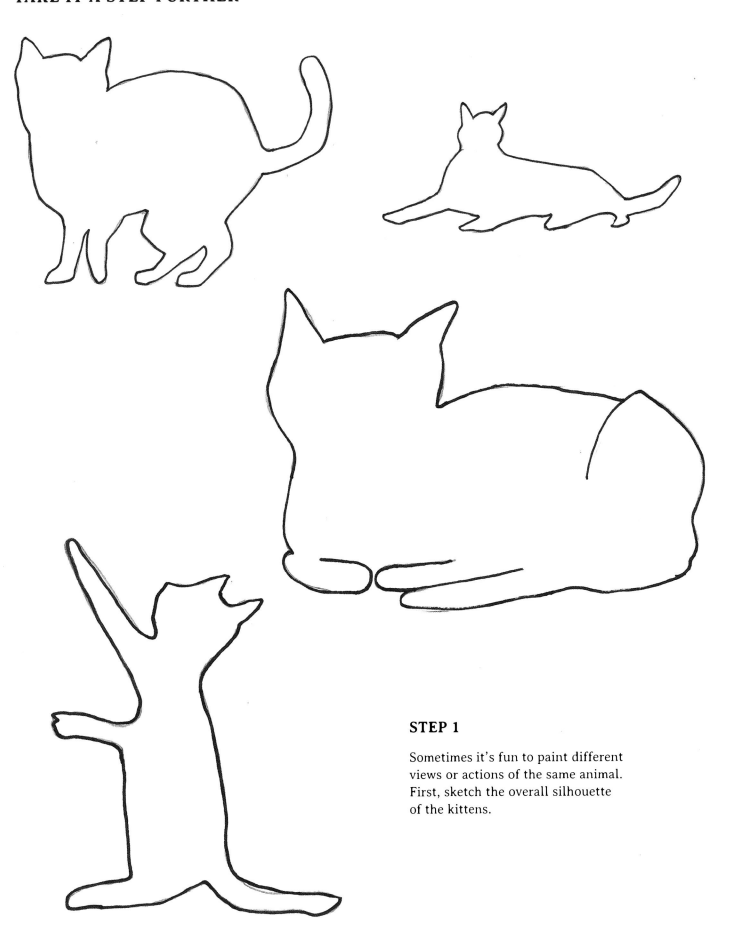

STEP 1

Sometimes it's fun to paint different views or actions of the same animal. First, sketch the overall silhouette of the kittens.

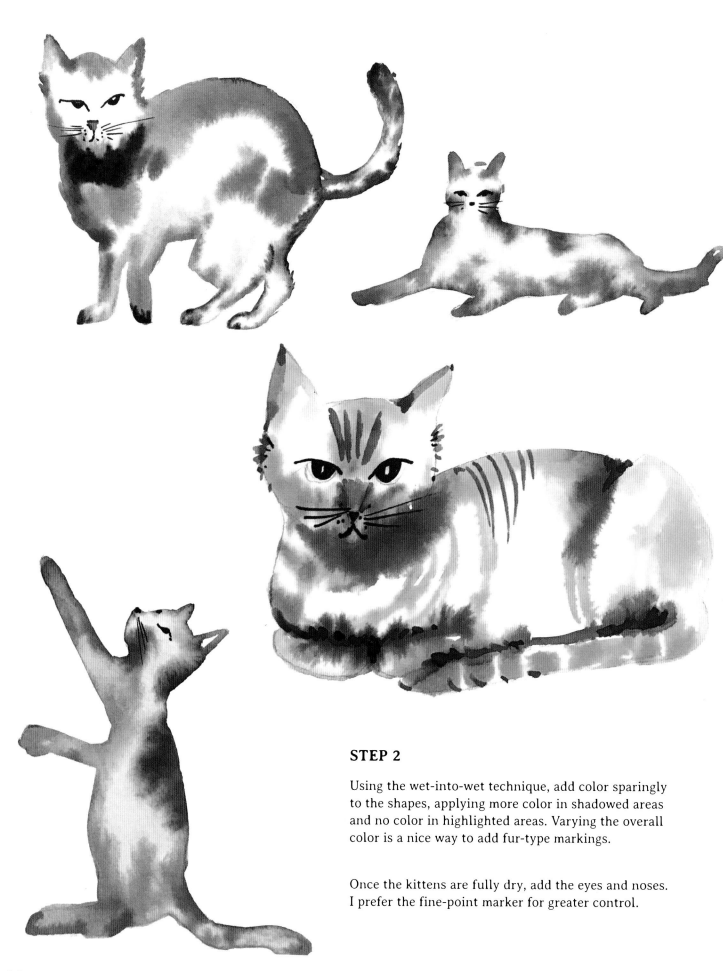

STEP 2

Using the wet-into-wet technique, add color sparingly to the shapes, applying more color in shadowed areas and no color in highlighted areas. Varying the overall color is a nice way to add fur-type markings.

Once the kittens are fully dry, add the eyes and noses. I prefer the fine-point marker for greater control.

STEP 3

The hard part is done—time to add the fun stuff! My kittens enjoy playing with my yarn and a butterfly friend.

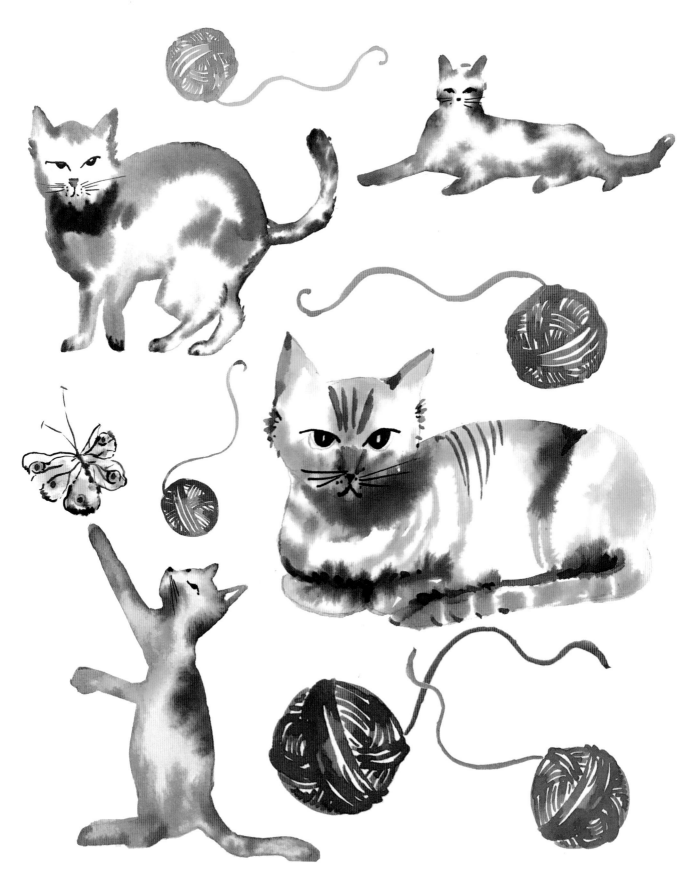

You can use these methods with any animal; try some imaginary pets as well as real ones!

Kitchen Collection

Your kitchen furnishings can make great still-life subject matter. Even plain white dishes, when set next to a bright yellow lemon, take on the reflected yellow glow and become interesting. The various shapes of kitchenware are also exciting. Look at different jugs, cups, and bowls, as well as the decorative details in their forms. Your dishes might have a boxier shape than the traditional round sets; this feature will make them fun to paint!

For this project, I collected jugs, a plate, a wooden spoon, and a tiny colored glass vase. Still life is always made more exciting by the addition of something organic, so even just a little twig with some buds or leaves will enliven your composition. If you don't have anything plant-like, a lemon, an orange, or another fruit or vegetable will provide some variety.

STEP 1

Arrange your objects so that there is some overlap between the objects; this creates a path for your eye to follow as you travel through the picture. With your setup ready, start by making a pencil outline, comparing measurements between objects to achieve the correct proportions.

STEP 2

Because there is a lot overlap in this piece, it's best to consider the object closest to you, and paint that first. Here, the branch with green leaves is the closest object and overlaps the plate in a number of places.

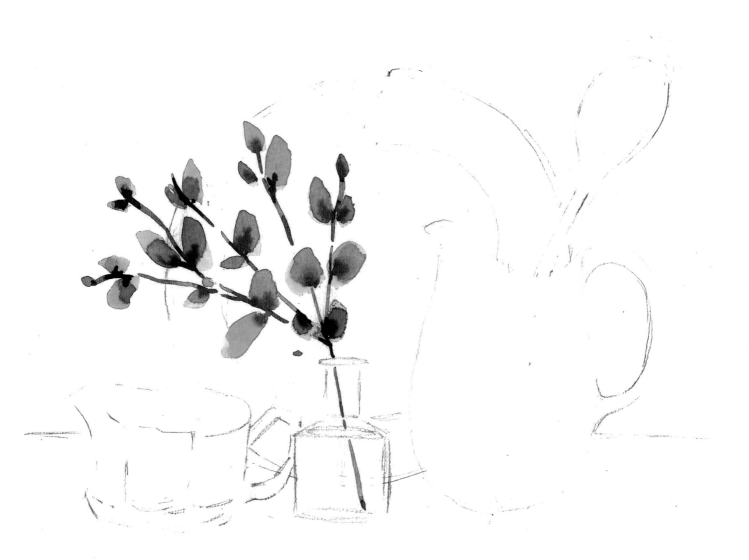

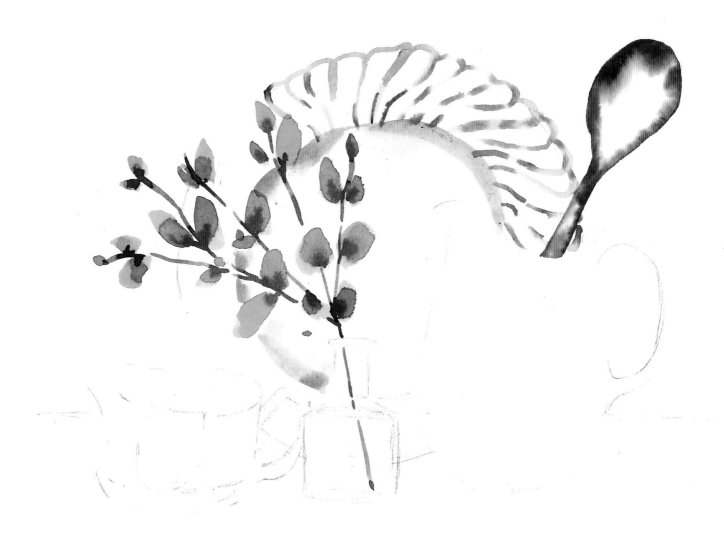

STEP 3

With the green spray established, move to the next bit of object overlap: the wooden spoon. The spoon is propped in the large jug but also covers an area of the back plate. Use the wet-into-wet technique to paint the spoon, and then start to tackle a bit of the plate. Because the plate has this interesting wave texture on the rim, use a linear method to define it, using just the tip of the brush to outline.

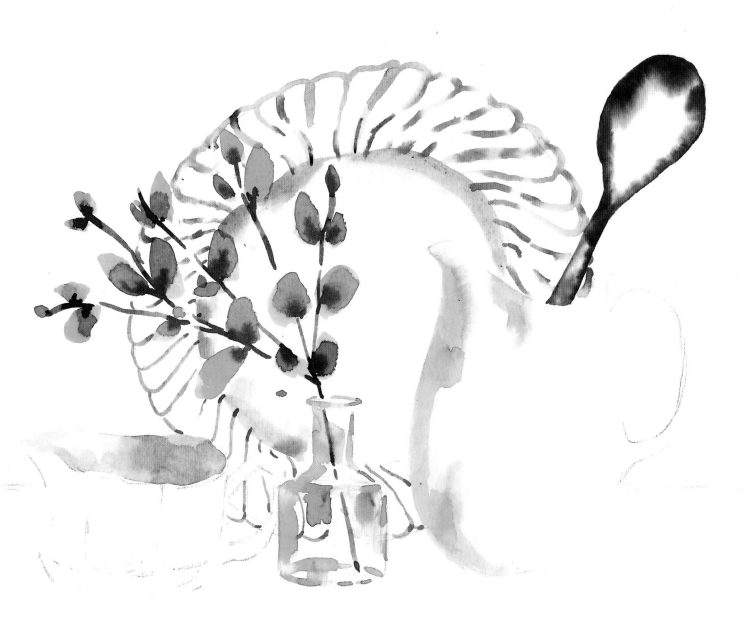

STEP 4

The rear layer of objects is now established, so you can focus on the three front objects. Begin by adding shadows to one side of those objects; detail can be added on top later.

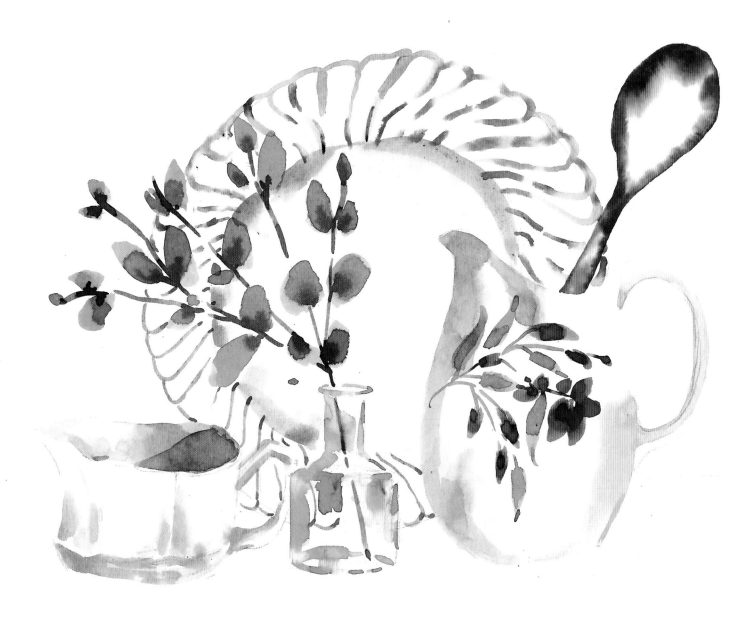

STEP 5

A limited palette will work to your advantage in this piece and prevent you from getting too "colorfully clownish." Add to the front items, using shades of the same colors you have already been using; this helps give unity to your piece. The challenge in painting predominantly white objects is to maintain restraint. Remember that in watercolor, you can always add more, but you can never take away! Leave some white areas and learn to get comfortable doing that; you will mature in your painting sensibilities.

Tip

Be sure to include reflected colors between the objects; the pink of the jug's design is reflected onto the small blue glass vase.

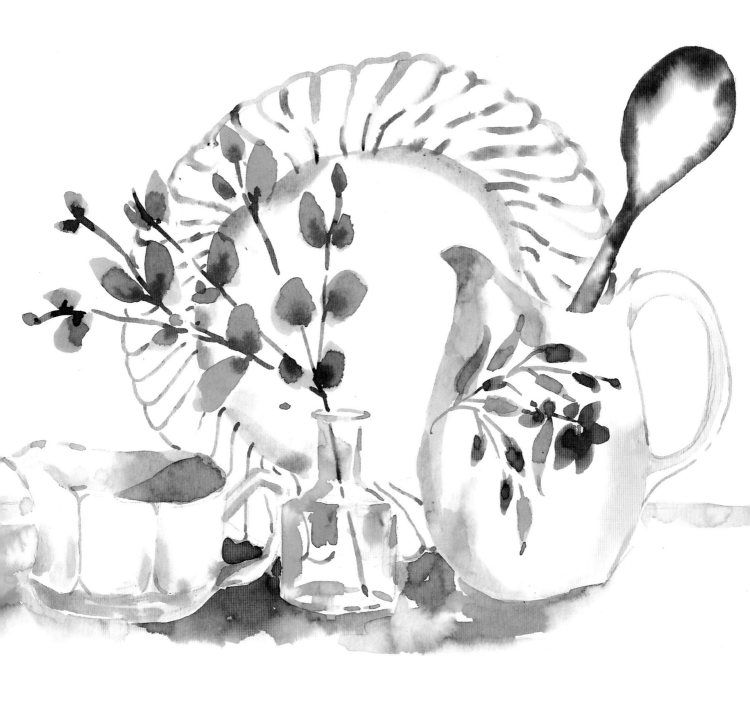

STEP 6

For the finishing touches, add some loose shadows underneath the objects. This is your final opportunity to create balance with the colors of the painting, so think about which colors you will use for each shadowed area.

Painting kitchen items is fun and will give you material to draw from when you illustrate your favorite recipe on pages 82-85.

MORE IDEAS

This is just one idea for recording a kitchen collection; what other common kitchen objects or foods would make an interesting painting?
The possibilities are endless!

Dresser Details

Let's try our hand at a little found still life now: the objects on top of your bedroom dresser. Choosing a dresser or tabletop as your subject offers a great exercise in creating a composition, and it is just a fun way to paint something decorative. You can imagine what you would want your dresser to look like—be as creative as you wish! I chose to take my painting in an aspirational direction, imagining my dresser top as if I were the owner of a vintage costume jewelry collection.

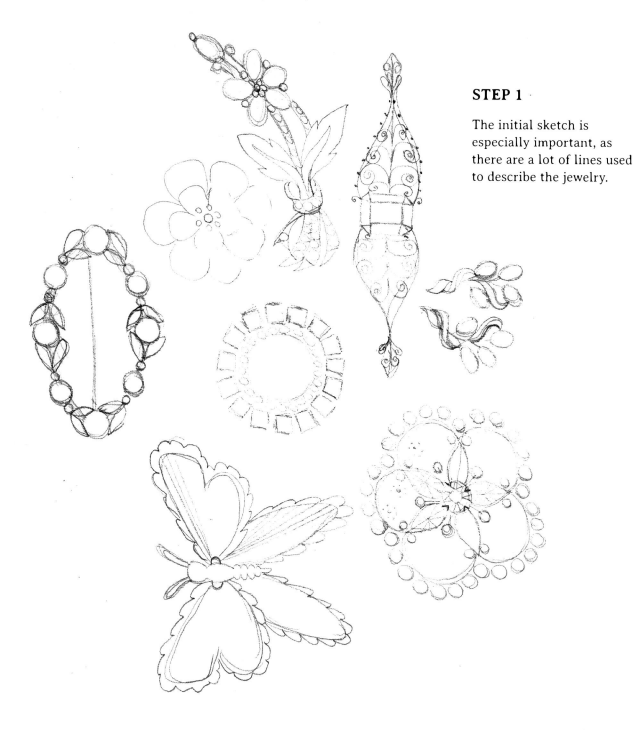

STEP 1

The initial sketch is especially important, as there are a lot of lines used to describe the jewelry.

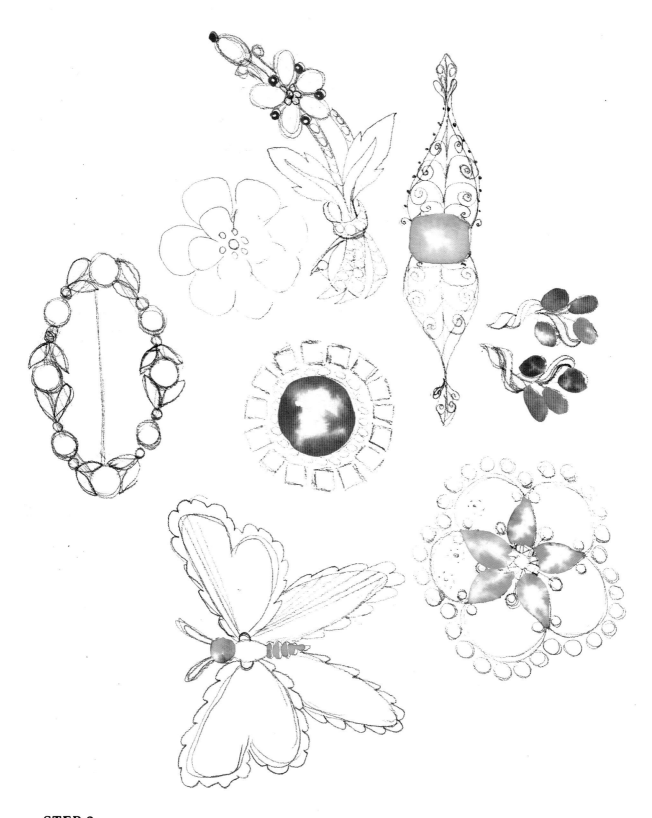

STEP 2

Next, use a wet-into-wet technique to paint the main "jewels." Wet the stone with plain water, and then drop in your color of choice—sparingly around the edges. As the paint dries, it will naturally leave some white highlights to give the illusion of facets on the stone.

STEP 3

Add more colorful stones, considering the balance of your colors as you go. An easy way to accomplish this is to use the same color in several different places on your painting.

Add a few shadows underneath the jewelry to create some depth. I've imagined that the light source is coming from the north at an angle to give a subtle shadow of the jewelry shape underneath.

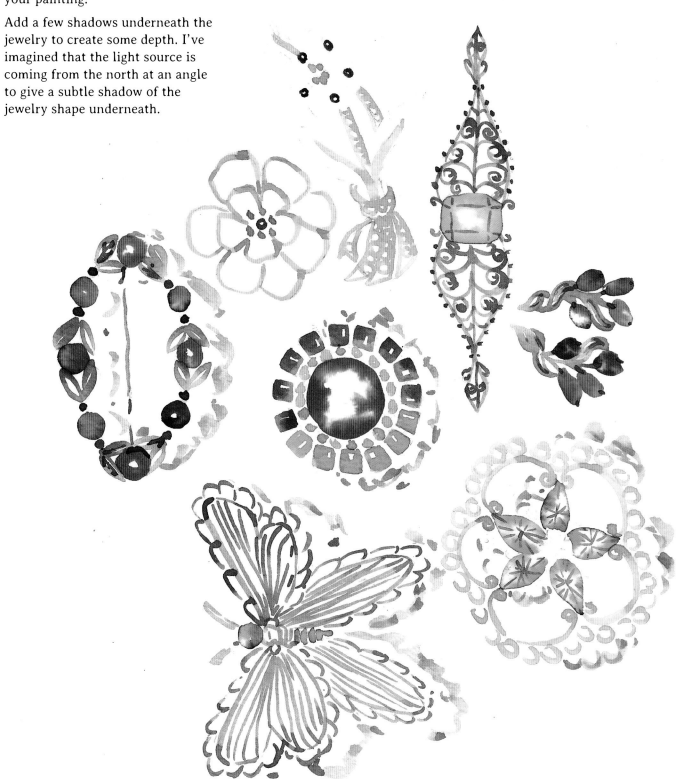

STEP 4

Finally, put the finishing
touches on the collection.
I like the linear quality of
the jewelry and enjoyed the
chance to use linework in a
decorative way.

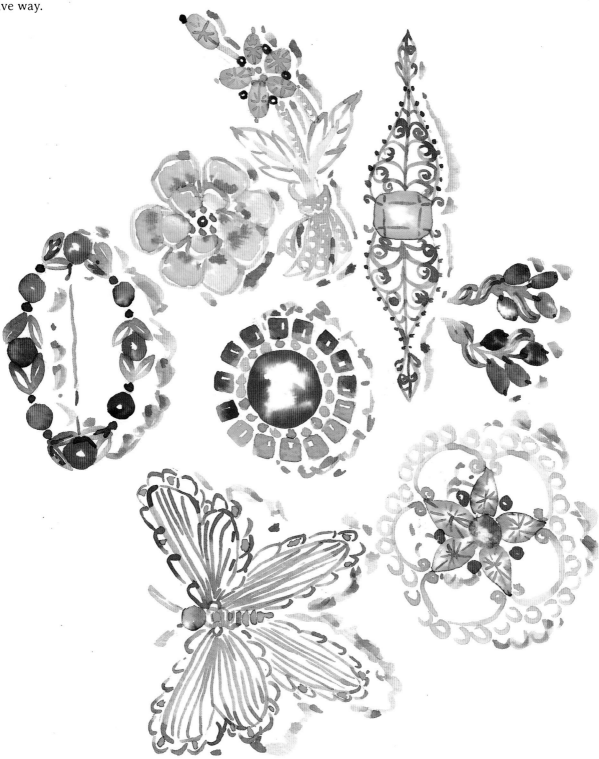

MORE IDEAS

Here are a couple of more dresser top pieces
that may inspire you!

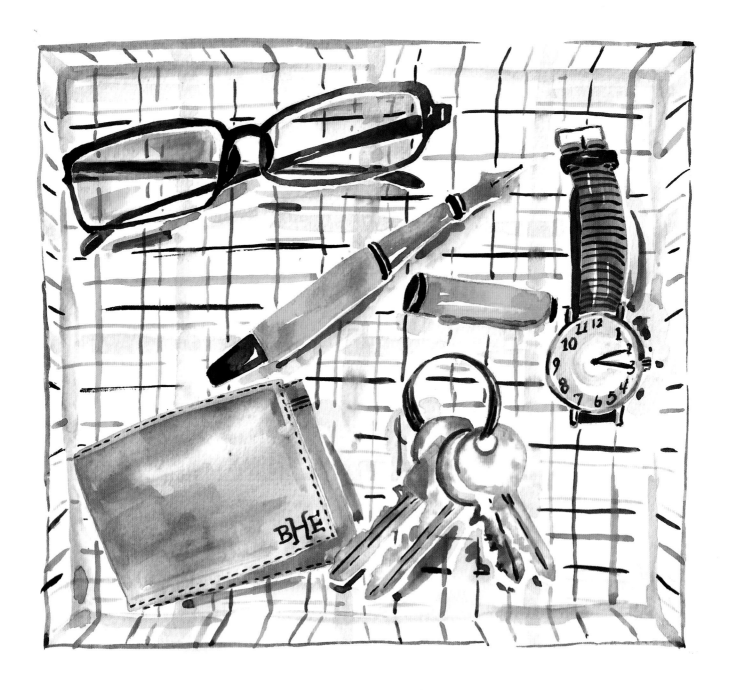

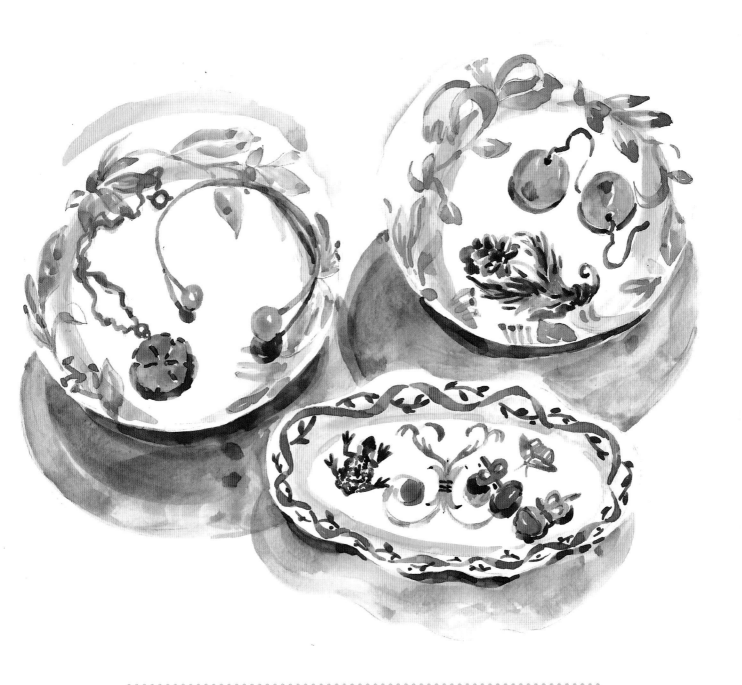

Tip
I keep my jewelry in pretty little dishes on my dresser. In this piece, the cast shadows of the jewelry are important to make the jewelry "pop" off the dish

Easy Interior: Letting in the Light

This project serves as a basic introduction to painting an interior. To keep things easy and to focus on the important areas of value (their relative light or darkness) and light, let's use a monochromatic color palette.

Look around your home and notice how outdoor light illuminates part of your interior. Alternatively, you can use a lamp to provide a light source. Try to keep it simple by only having one light source: outdoor light shining in during the day, or indoor light at dusk or night.

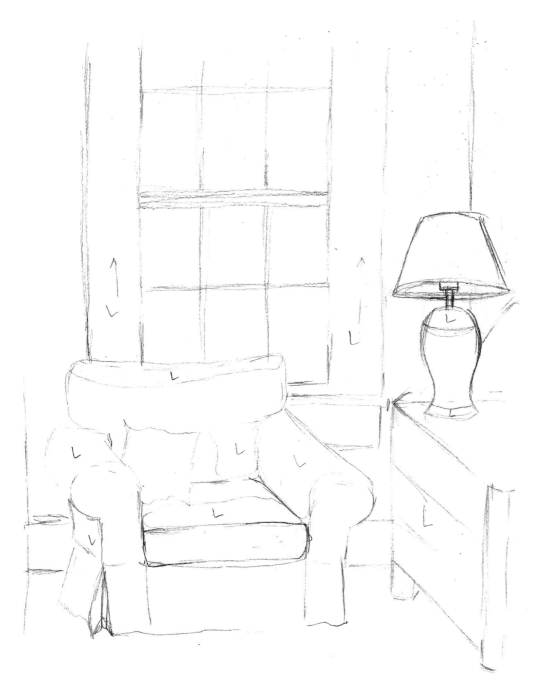

STEP 1

Begin by making an initial sketch. I've chosen a corner of my living room. You don't need to go crazy with little decorative details. Rather, focus on observing the lights and darks, as well as the values, and communicating them correctly.

Notice that on my sketch, I have marked an "L" in some areas. This is to remind me that these are my "lightest" areas and should be kept white.

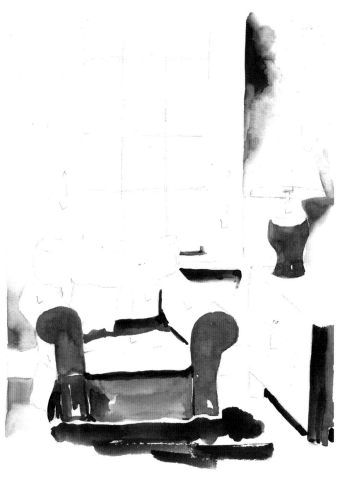

STEP 2

Once you've designated the lightest values, paint the darkest dark areas.

STEP 3

From the darkest areas, move to a midtone range of values. I've used the wet-into-wet technique in areas of the chair and tabletop to allow for some more natural-looking highlighted areas.

Tip

Look closely at your scene. Sometimes it's helpful to squint your eyes to remove details and see only value.

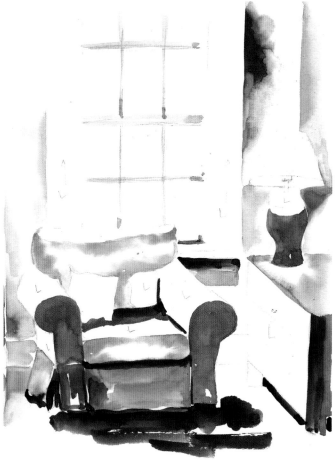

STEP 4

Finally, add the finishing touches. Flesh out the remaining areas and choose their values by comparing them to the other areas of the painting.

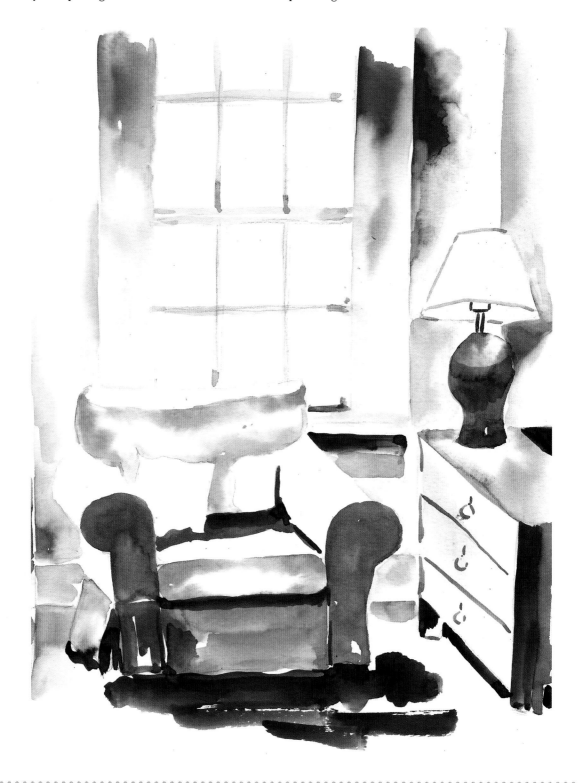

Our eyes are amazing instruments and can "fill in" visual information
even if it isn't explicitly shown in a painting. This is the best connotation
of "leaving it to your imagination," I think!

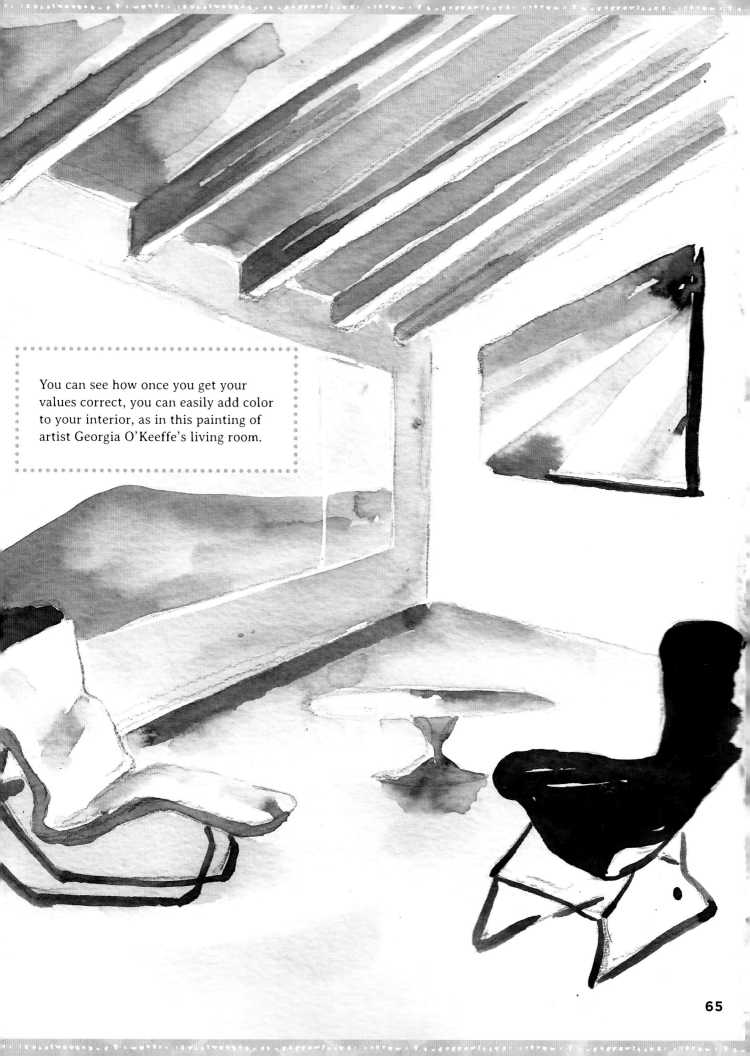

You can see how once you get your values correct, you can easily add color to your interior, as in this painting of artist Georgia O'Keeffe's living room.

Colorful Interior

Now that we have observed the values of an interior scene—the lights and the darks—let's paint an interior in color, using values to guide us. In the monochromatic interior (see pages 62-64), we started by painting the darks in first and ended with the lightest lights. For this piece, we will move in the opposite direction: beginning with the lights and working up to darks.

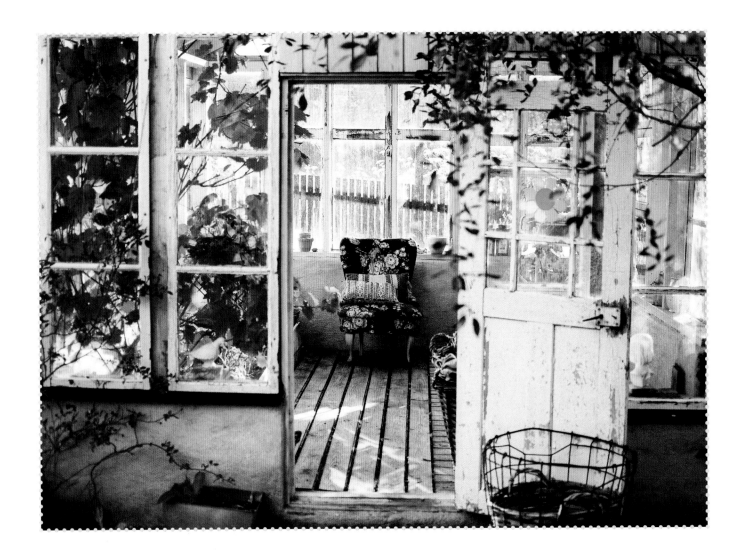

STEP 1

Start by finding an interior scene that you'd like to paint. It could be in your own home, or it could be a pretty photo seen elsewhere. I found this intriguing little greenhouse room and the colors won me over.

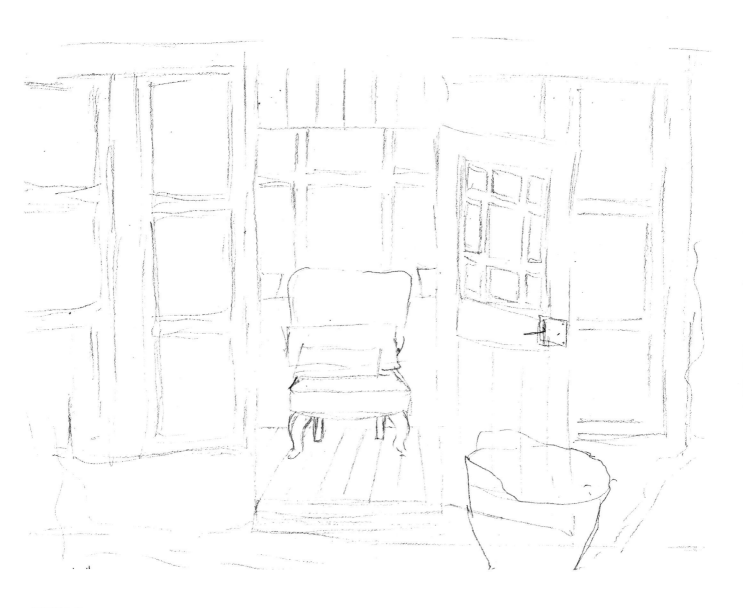

STEP 2

Loosely sketch the important parts of the scene, such as the chair and pillows, the placement of the doorway, and the windows. This will be an intentionally loose painting, so leave pencil lines as a feature.

STEP 3

Determine the lightest parts of the picture, and loosely paint those in.

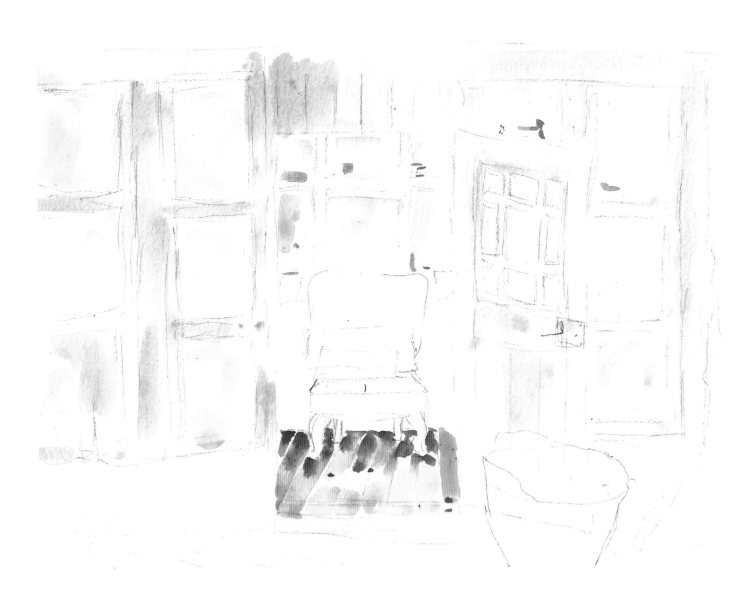

Tip

Here's a tip for staying loose: Hold your brush at the very end of the handle. You
lose some control, but you can make more energetic brushstrokes.

STEP 4

Continue by adding slightly darker values, remembering always to leave some little patches of white for the light to reflect from. Notice the very brightest area on the floor in front of the chair is the white of the paper. Simply paint around the areas of lightest value.

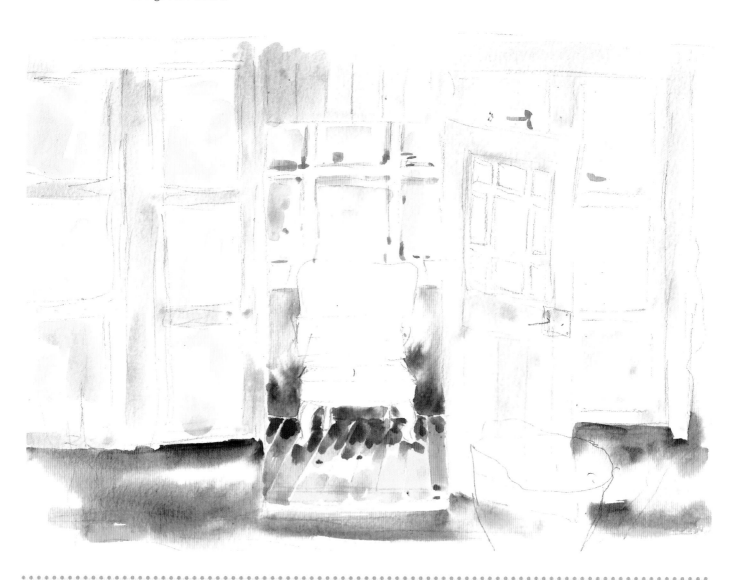

Tip

Another way to stay loose with your brush is by holding it like you used a marker as a kid. With larger strokes coming from your whole arm and not just your wrist, you can "color in" larger areas.

White knuckles and fingertips are a sign you're getting too tight with your brush! Take a deep breath, relax, and loosen that grip. Remember that there is always more paper. If you need to buy less-expensive paper to help yourself feel free to use it up, then do it!

STEP 5

Now that the large areas of color are established, you can begin to add details. The very darkest darks, the green foliage of the plants inside, will be the last step of the painting.

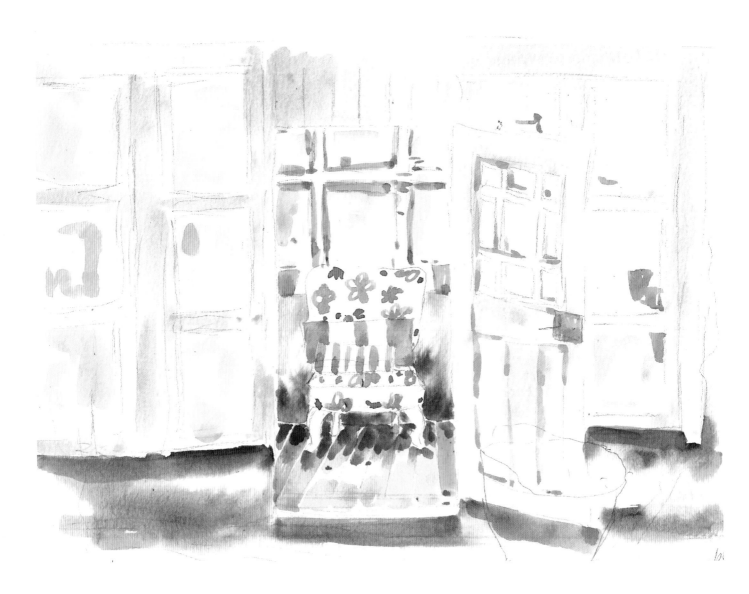

Tip

Details don't have to dominate a painting. Here, the pillows and chair add some interest, even though they are a small piece of the picture. To paint fun patterns, add your pattern element first, like flowers or stripes, and then add the background color around it. This is a fun place to experiment with new colors you might not usually use!

STEP 6

Line work is next. Add details to show texture in the outer walls and floor by "drawing" lines with your brush. The metal wire basket is also painted in this way.

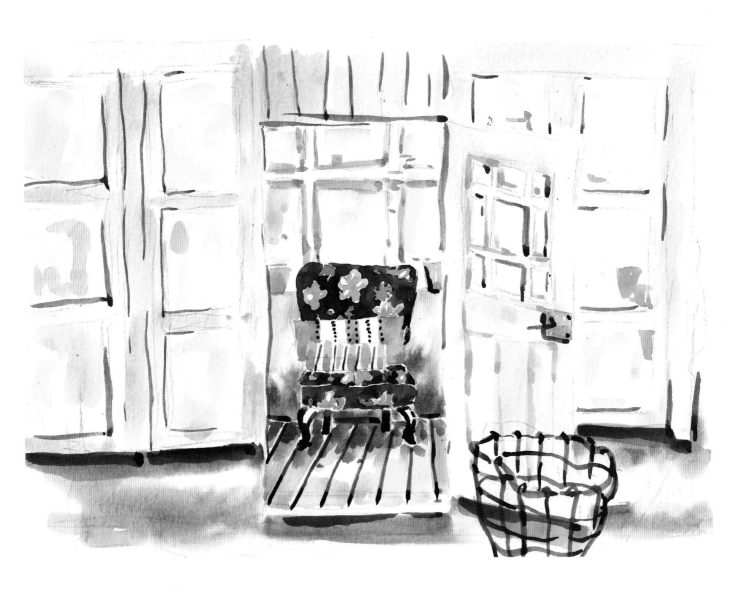

Tip

Lines to indicate textures can be "sketchy." You do not need to make all
these lines perfect to give the overall impression of texture.

STEP 7

Finally, paint in your darkest areas. Here, they are the green plants seen through the windows. Just a few leaves of a distinctive shape will give the correct impression, and most of the other foliage is simply squiggles with the brush. Watercolor always dries lighter, so you may have to retouch the darkest areas after the first layer has dried. Add any other finishing touches needed to bring a pleasing balance to the painting.

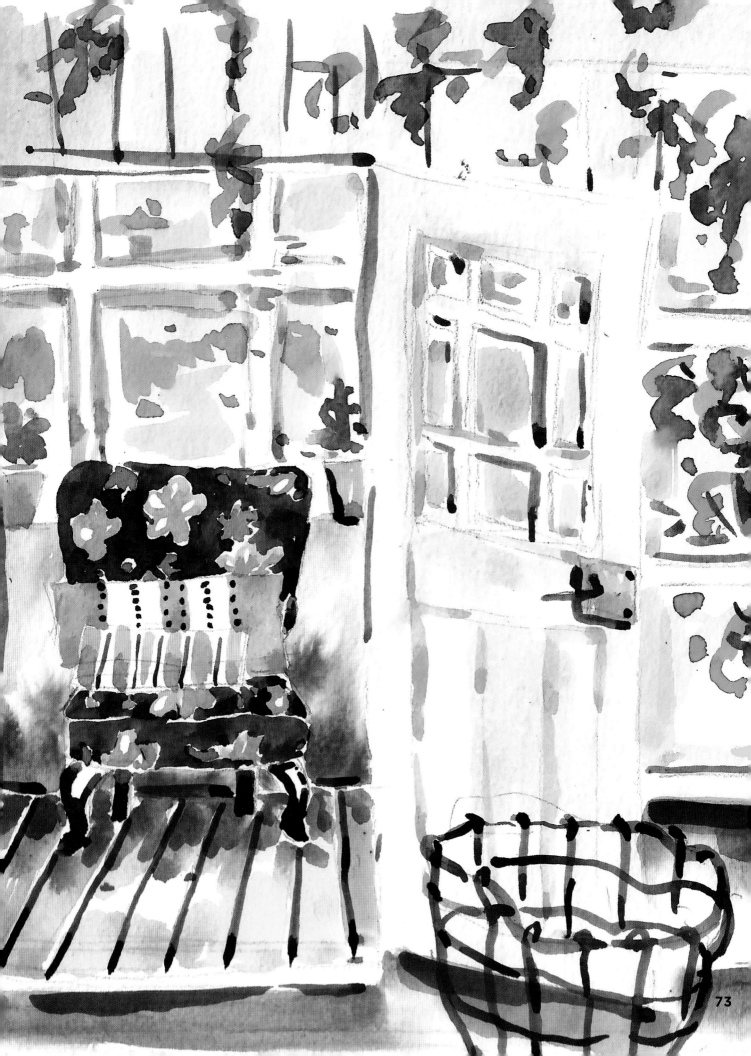

Painting in a Series: The Weather Outside Your Window

Often the most inspiring subjects are the ones closest at hand. Look at historical artists and notice that they frequently painted skies, landscapes, views of interior rooms, or tables set with plates and food. For this exercise, you will observe the weather outside your window and make small, loose sketches of the various things you see.

Claude Monet painted a famous series of the Notre-Dame Cathedral. He made countless paintings of the same spot in different lights and at different times of day. His example will serve as our inspiration.

Tip
This is also a great exercise for a sketchbook, but if you don't have a sketchbook to use, simply use pieces of paper and fit up to four small paintings on each sheet.

CLIMATE QUESTIONS

As you begin to paint these small records of daily weather, ask yourself some questions to help you paint:

- What colors do I see in the sky? How do the colors change based on time of day or weather?
- Are there clouds? What kinds of shapes or colors are the clouds?
- What is in the landscape? Buildings or natural spaces? What are their colors? Do they change color in different lights?

Here are some examples of small, loose landscapes from my farm:

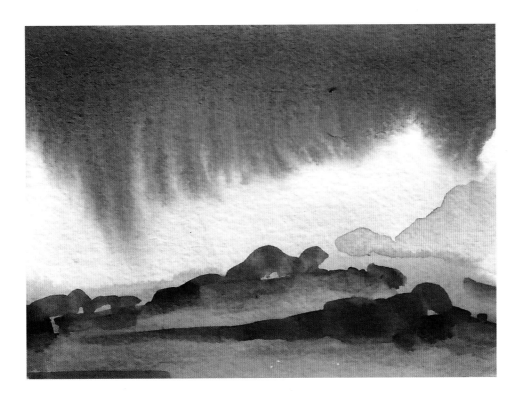

This was a rainy day. To get the rain effect, I wet the whole sky area and put dark color at the top; then I held the paper up vertically to assist the pigment in bleeding downward to mimic rain. Because it was a gray day, the colors in the landscape are also faded and muted.

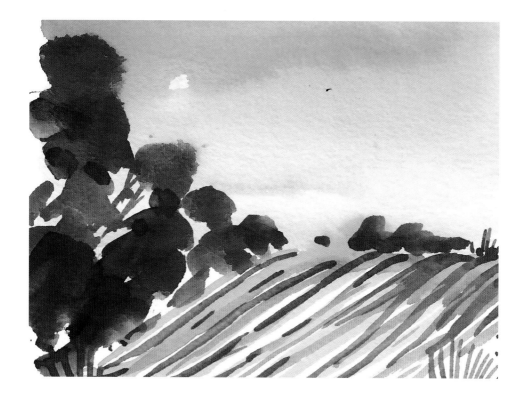

This view shows our field planted and just beginning to sprout. The rows of baby green corn alternate with the brown dirt treads, and the sky in early summer is bright and blue, making all the colors seems more vibrant.

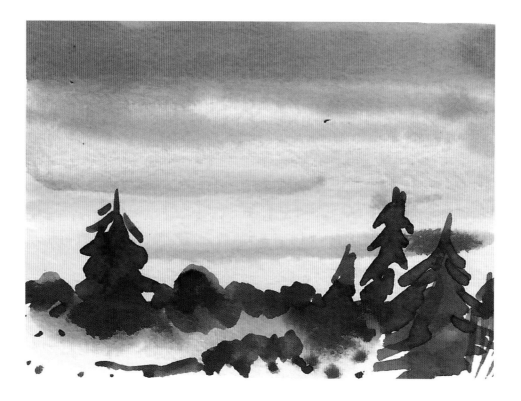

Winter on our farm brings beautiful sunsets, which we see through a grove of spruce trees. The glowing, warm colors of the sunset behind the trees make the trees appear a very dark blue.

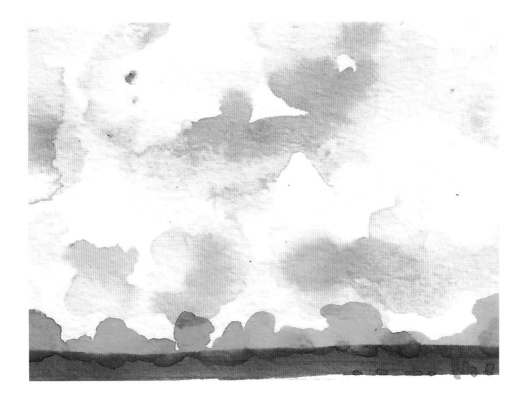

Cloud formations, or "cloudscapes," are fun to paint. Start by painting around the shape of the clouds to preserve the whites. You can always add shadows to the clouds in other colors to help define and give them shape. Some types of clouds are seen on bright days, and others on dark and stormy days. Because the clouds are the feature here, the horizon and landscape are marked by a simple line.

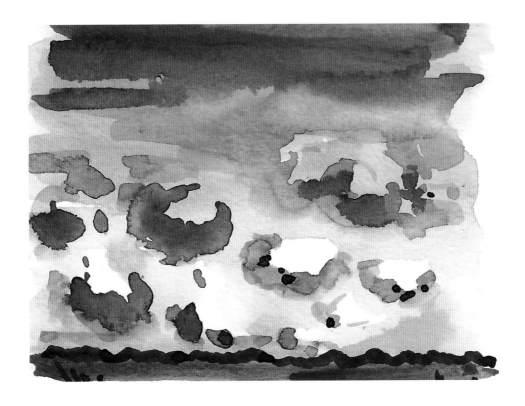

TYING IT ALL TOGETHER

Once you've made a number of small studies of various kinds of weather, you will likely have a favorite that you'd like to make into a larger painting. I find the colors of the sunsets beautiful, so I chose to paint a sunset on a 9" x 12" sheet of paper.

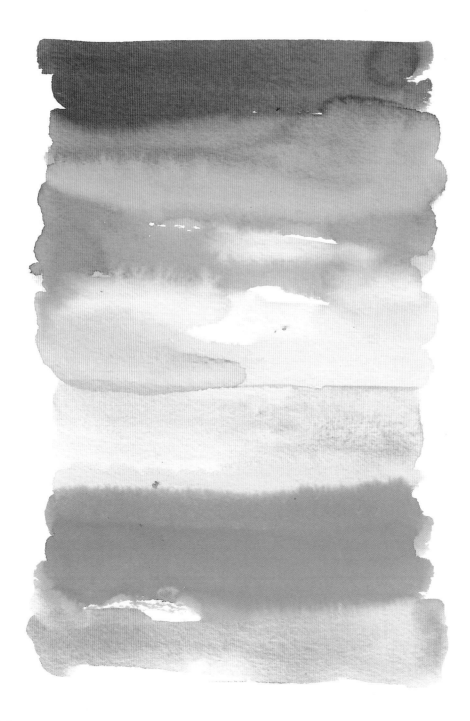

STEP 1

Begin with the colors at the top of your sky and work downward. It was important to me to get a variety of purples, pinks, and oranges in this sunset, so I washed them across the sky and allowed them to bleed into each other. As you get to the horizon line, transition to the ground colors until you are at the bottom of the landscape.

STEP 2

When this base layer is dry, add some details to the landscape, starting at the farthest tree line. Atmospheric perspective comes into play when you paint landscapes, so remember this simple rule: as you move backward in space, objects become bluer and duller. Add finishing touches to suggest some texture in the foreground, such as dots or grasslike brushstrokes.

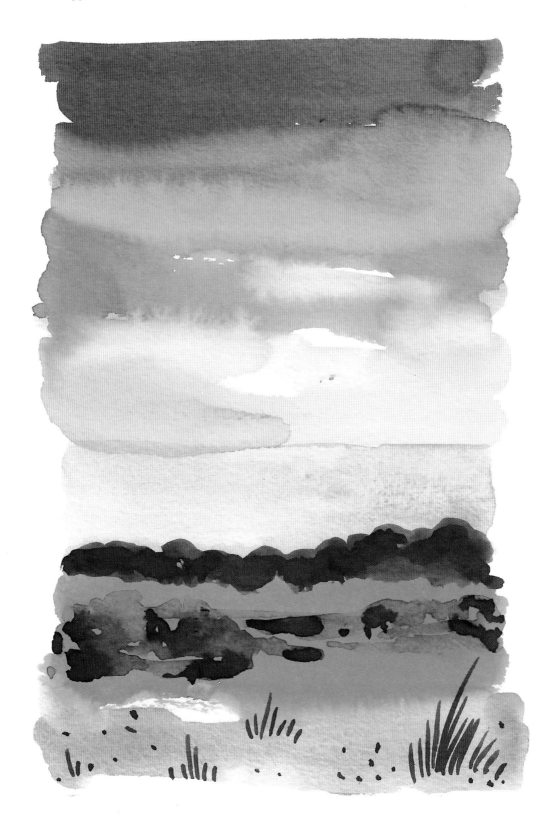

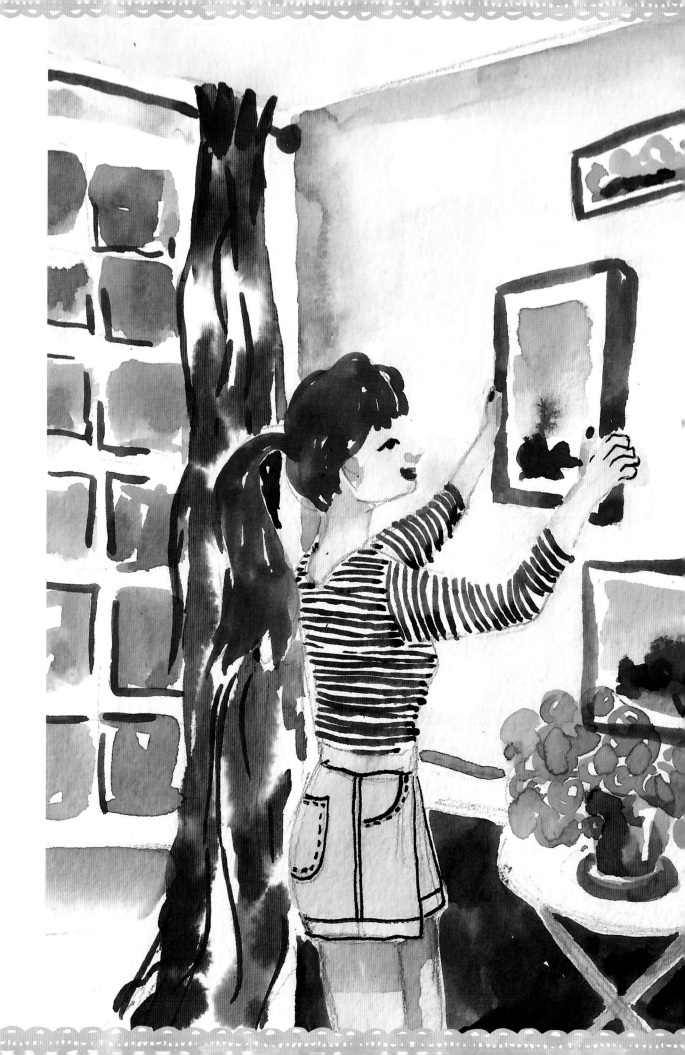

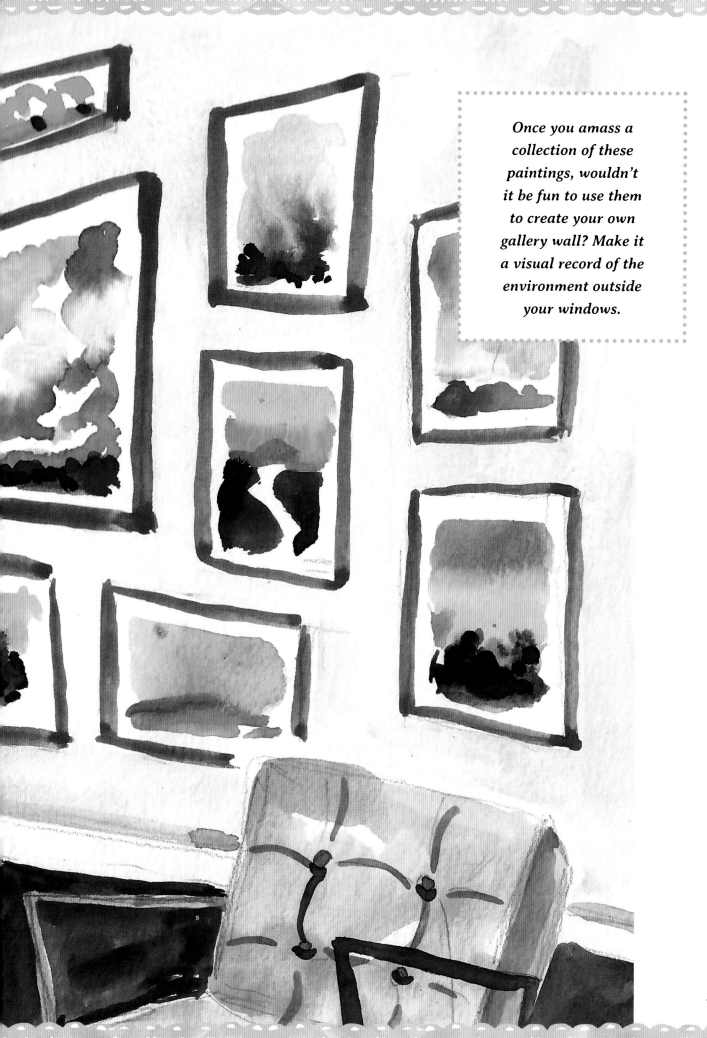

Once you amass a collection of these paintings, wouldn't it be fun to use them to create your own gallery wall? Make it a visual record of the environment outside your windows.

Illustrate a Treasured Recipe

What could be more personal and thoughtful than illustrating a special family recipe? Maybe there's one particular recipe that stands out in your family, or perhaps it's a whole collection of recipes! Bringing a set of your illustrated recipes to a cookie exchange is a really nice touch.

With something as special as a recipe, I recommend that you start by writing the recipe in your own handwriting. I have some heirloom recipes from my family that were written in my great-grandmother's hand, and they are very special.

STEP 1

Write your recipe on watercolor paper, leaving some margin around the edges to add your illustrations. Recipes that are relatively brief work the best.

Hannah's Violet Hill Jelly

2 cups violet flowers

4 cups boiling water

1/4 cup lemon juice

4 cups sugar

1 package powered pectin

With the violet flowers in a large canning jar, add
4 cups of boiling water to make a tea. Cool and allow
to steep refrigerated overnight.

Strain tea into a large saucepan. Add 1/4 cup lemon juice.
Add package of powdered pectin and bring to a boil. Add
4 cups of sugar and return to a boil. Boil 1-2 minutes.
Remove from heat and skim.

Pour jelly into hot jars and allow 1/4-inch headspace.
Cover with lids and rings and process for 10 minutes
in a water-bath canner.

After 24 hours, make sure lids have set.

STEP 2

Now you get the fun of adding illustrations to decorate the recipe page. My daughter loves making violet jelly in the spring, and that was the inspiration for my recipe painting here.

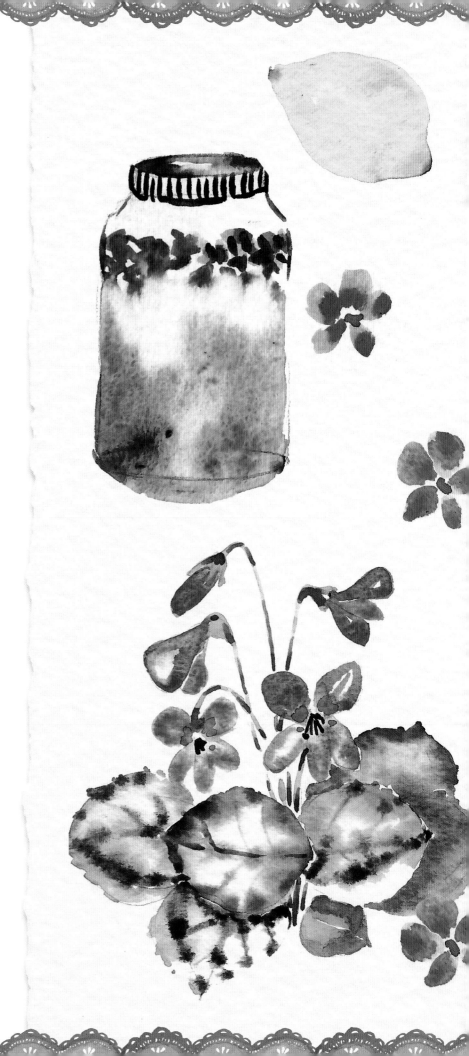

Hannah's Violet Hill Jelly

2 cups violet flowers

4 cups boiling water

1/4 cup lemon juice

4 cups sugar

1 package powered pectin

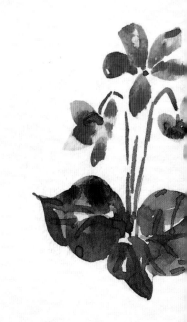

With the violet flowers in a large canning jar, add
4 cups of boiling water to make a tea. Cool and allow
to steep refrigerated overnight.

Strain tea into a large saucepan. Add 1/4 cup lemon juice.
Add package of powdered pectin and bring to a boil. Add
4 cups of sugar and return to a boil. Boil 1-2 minutes.
Remove from heat and skim.

Pour jelly into hot jars and allow 1/4-inch headspace.
Cover with lids and rings and process for 10 minutes
in a water-bath canner.

After 24 hours, make sure lids have set.

Vegetable Garden Plans

Have you seen the interesting geometric arrangements that fancy formal gardens used to have? This project is a take on those ornamental gardens and is a fun way to play with groupings of colored shapes applied to the design of a vegetable garden.

Tip

If you do an online search for "formal garden plans," you will find a wealth of interesting shapes and ideas for creating your own veggie garden layout.

STEP 1

Choose your desired garden layout. I wanted to keep my shapes simple and compact for a basic summer kitchen garden. Because the designs are all based on geometric shapes, you don't even need to sketch anything to begin—just dive in and paint with some pale-green colors!

You can see my layout is simple and designed around a circular planter in the middle. Leave some white borders around the defined garden beds to allow you to add some grass or other details.

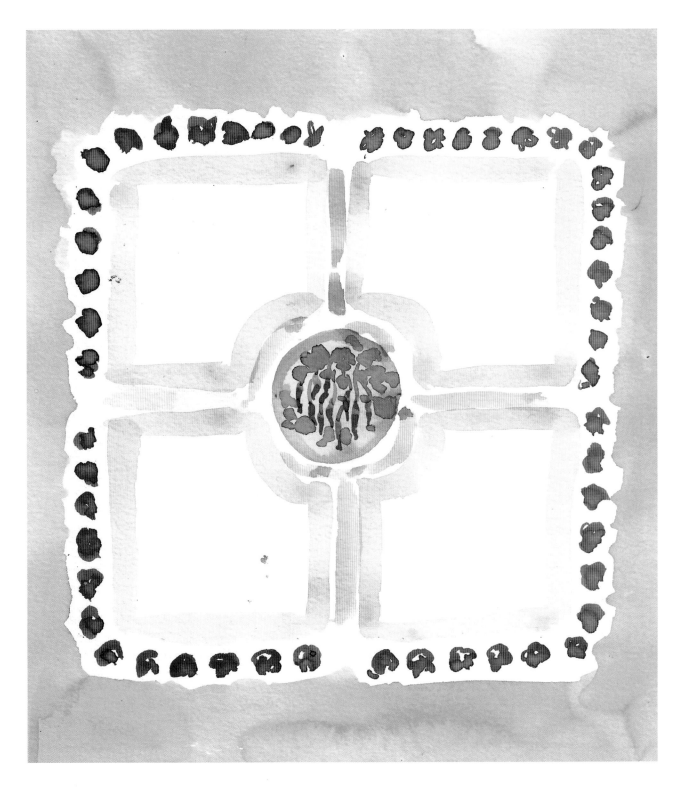

STEP 2

It's traditional to plant marigolds around vegetables to deter pests, so you can add some vibrant orange flower heads as a border around the garden. And then in a different shade of green, add some lawn areas. The center of this garden is for pole beans, so I paint those loosely, just giving a suggestion of what they are by their shape and color. It is a fun challenge to paint things small because you must determine the identifying characteristics. Usually, these are shape and color.

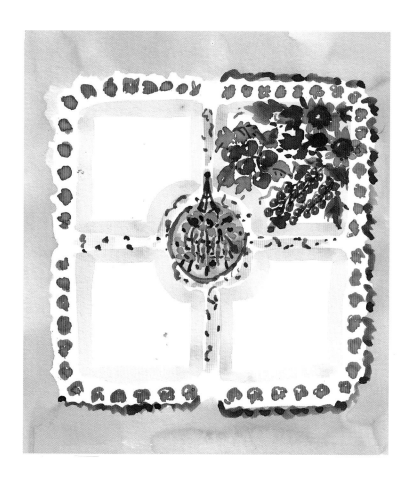

STEP 3

Now the fun parts: Painting (or planting!) the beds. Sunflowers and tomatoes make a colorful combination. By painting both large tomatoes and smaller branches of cherry tomatoes, I can give this section some nice variety in size. The sunflowers offer a unique shape and different color.

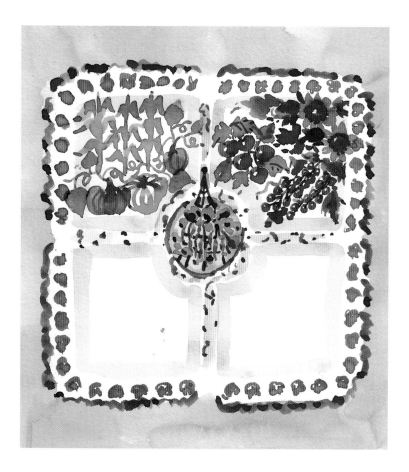

STEP 4

The next section includes bright, summer-green corn, with its tall stalks and armlike sheaves where the corn fruits. Short, colorful, heirloom pumpkins make a nice contrast to the corn.

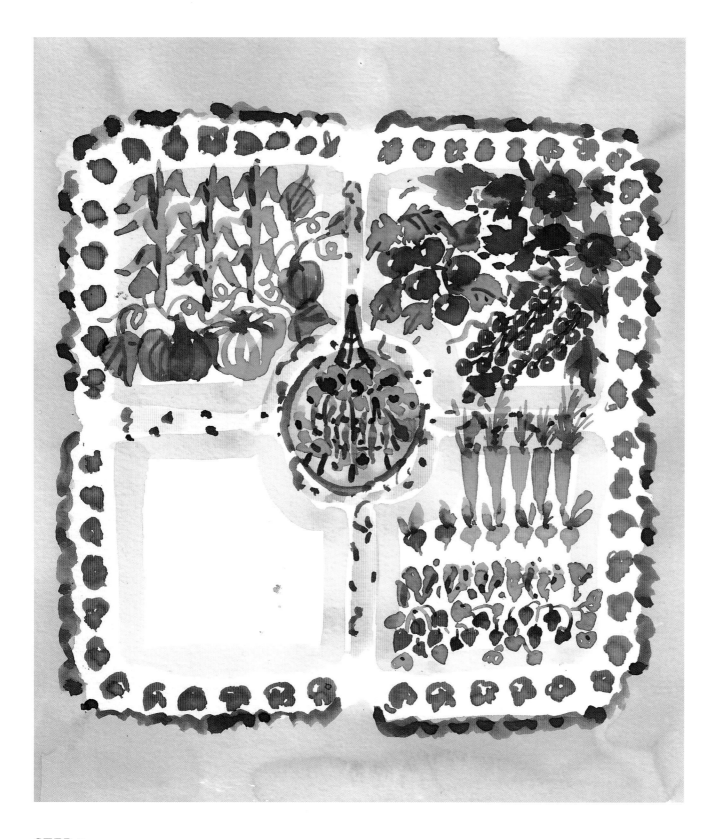

STEP 5

With lots of different colors and shapes, this third section comes alive with rows of carrots, lettuce, radishes, and strawberries. Pay close attention to the unique shapes of each fruit or vegetable and its leaf shapes, and you will be able to accurately give the suggestion of what they are with merely an intentional blob of paint.

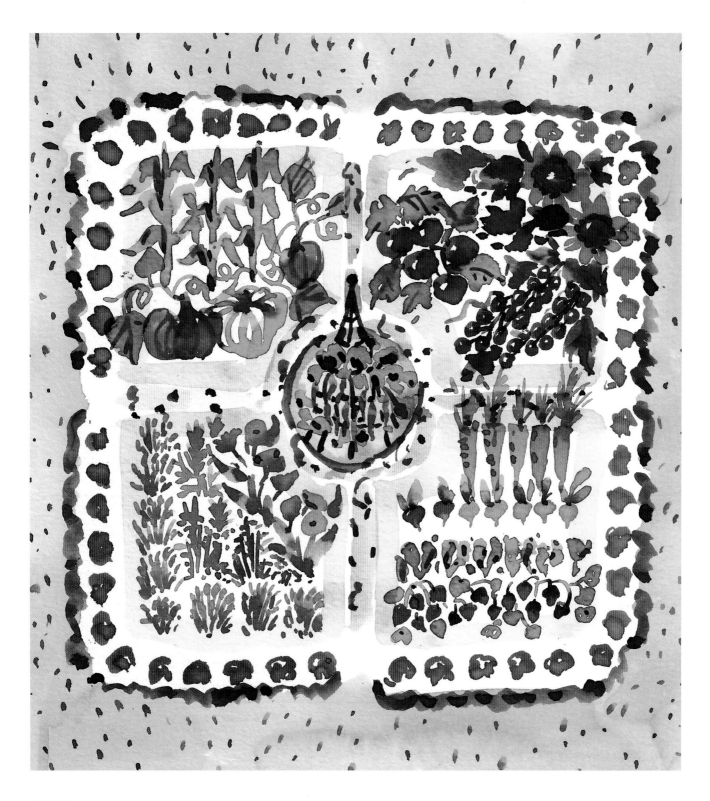

STEP 6

Isn't it fun "planting" your garden? There are no pests, weather, or work to worry you! My last garden bed contains my beloved lavender plants to make me happy and introduce a new color: purple. A mix of delicate, herblike shapes suggests thyme, rosemary, and oregano, while the inner edge has some pale-orange calendula flower heads peeking up.

The final touches to this piece include small lines to suggest grass around the outer border and a darker, deeper green around the marigolds to make them pop.

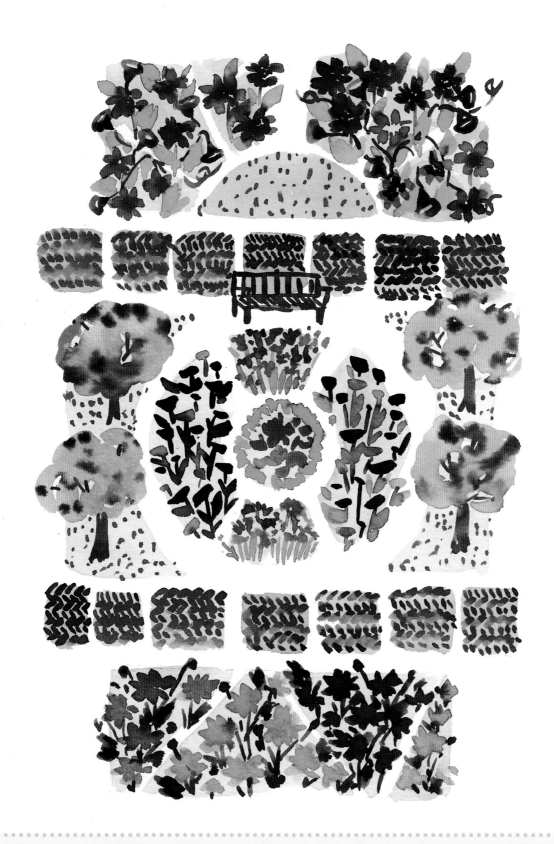

Remember that you don't have to justify your gardening decisions to anyone with practical experience, so have some fun with this! I enjoyed it so much that I created a dream flower garden, where my favorites bloom at exactly the same time, all summer long!

Gardening Tools "Collage"

This project aims to expand your range of watercolor techniques by utilizing a masking fluid border around the composition. White flowers are very difficult to paint in watercolor because they are the color of the paper, but by using masking fluid and painting the negative space around the flowers, the white flowers really pop!

Masking fluid is a sticky, water-resistant adhesive that is painted on wherever you want to preserve white. Once the masking fluid dries, you can paint the negative space around those shapes with a wash. Finally, remove the masking fluid by scrubbing with the side of an eraser to remove the sticky film. Voilà! Your pristine white remains.

STEP 1

In this garden piece, I was inspired by thoughts of the coming spring and getting back to work in the dirt.

Lightly sketch various tools and accessories in a "collage" style around the paper. Leave some room around the edge of the paper for the painted border; we will do this last.

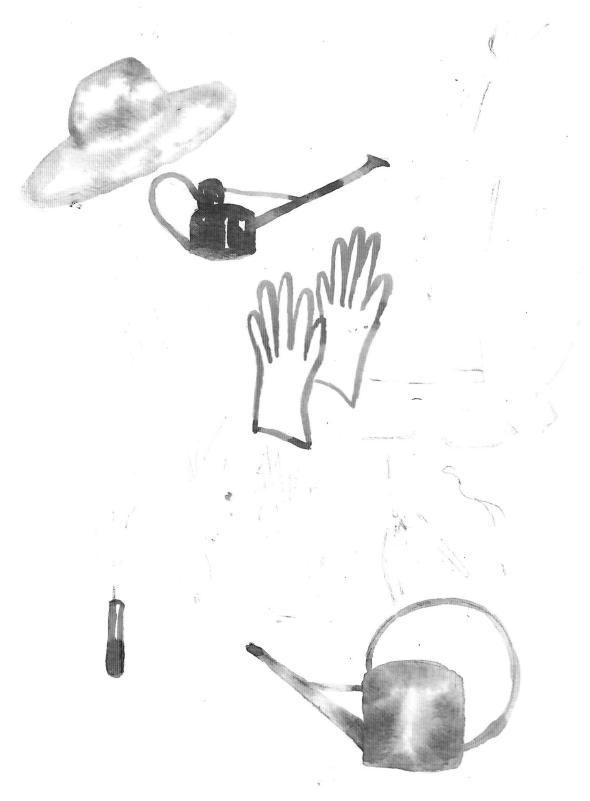

STEP 2

I love the natural highlights that come from using a wet-into-wet technique and knew I wanted to utilize this for the straw hat and the shiny green watering can. The highlights give a feeling of light and texture, so this technique is perfect for objects or animals with interesting surfaces.

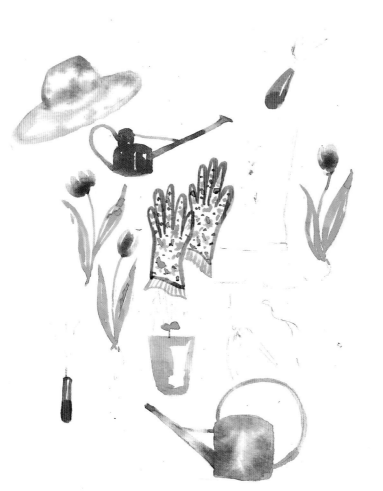

STEP 3

Continue to add details, thinking about color balance around the entire composition.

STEP 4

Finish the first layer of all the items, painting wet-into-wet for the shiny rubber garden boot as well. Once all the paint in this layer is dry, you can add the final details.

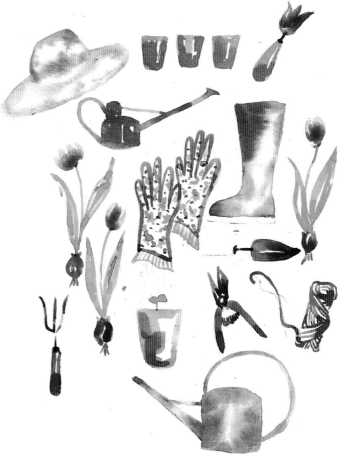

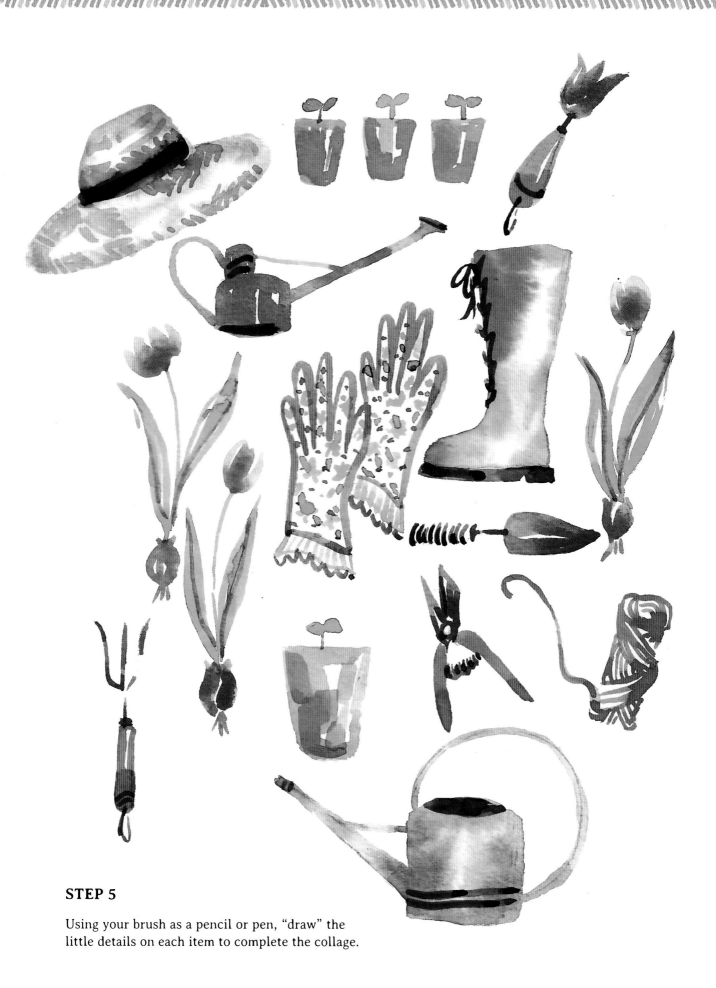

STEP 5

Using your brush as a pencil or pen, "draw" the
little details on each item to complete the collage.

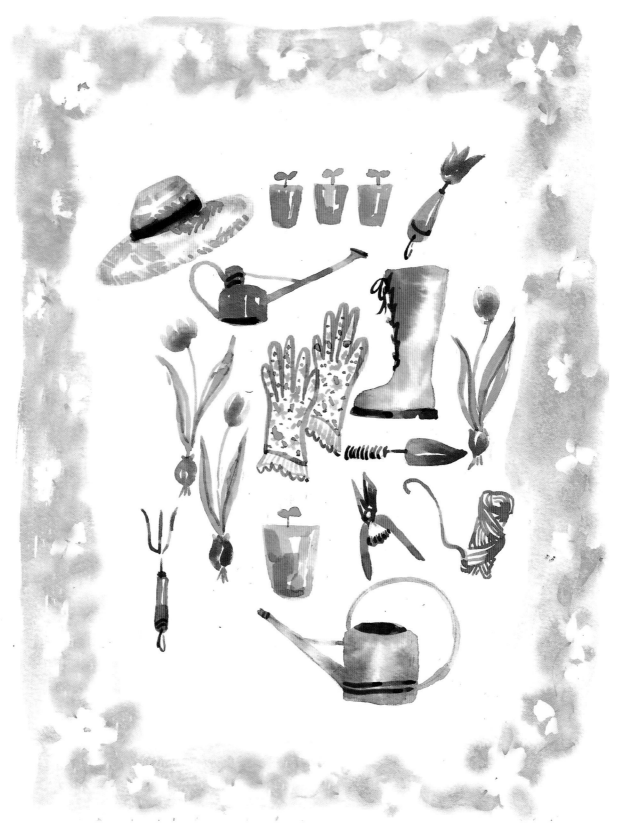

STEP 6

Now for the fun part! Grab your masking fluid and paint small brushstroke flowers around the border of the painting. Allow to dry fully. Choose the color for the "background" of the flowers; I chose a fresh, vibrant sky blue. With a brush full of paint, wash the color over the masking fluid around all four sides.

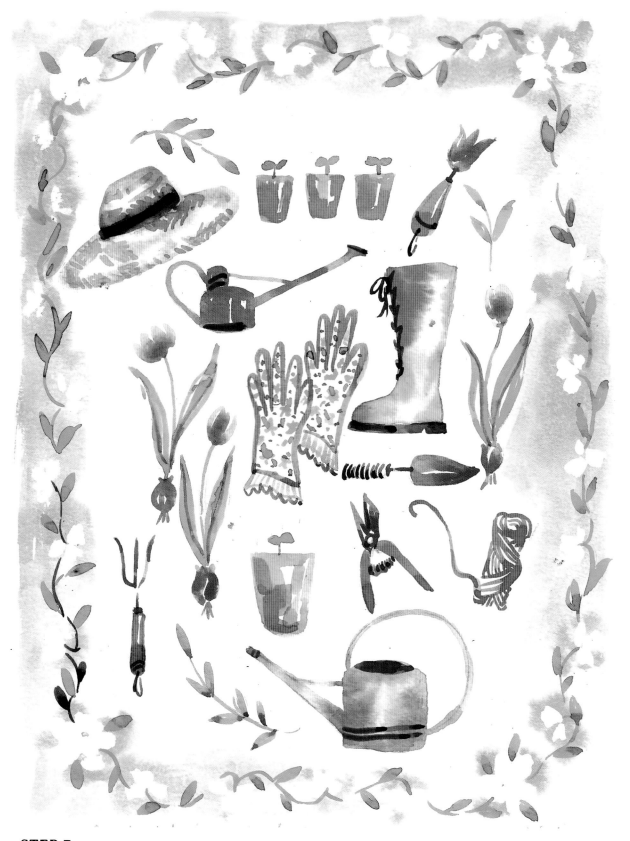

STEP 7

Once your wash is fully dry, use a pencil eraser to gently rub at the masking fluid; the eraser will pick it off the paper and assist you in pulling the rest off. Remove all the masking fluid this way and enjoy your sharp flowers. Now you can add some leaf and stem details trailing around the edges and fill in any empty white areas with little leaf sprigs.

Fauna Outside Your Window

Until recently, I never appreciated the simple joy that watching birds can bring. It is truly an occupation that requires no supplies or special training, and all you need to do is look out your window! In this project, I've demonstrated how to paint some of my favorite backyard bird friends. You can use the techniques shown here for any birds that are unique to your location.

BLUEBIRDS

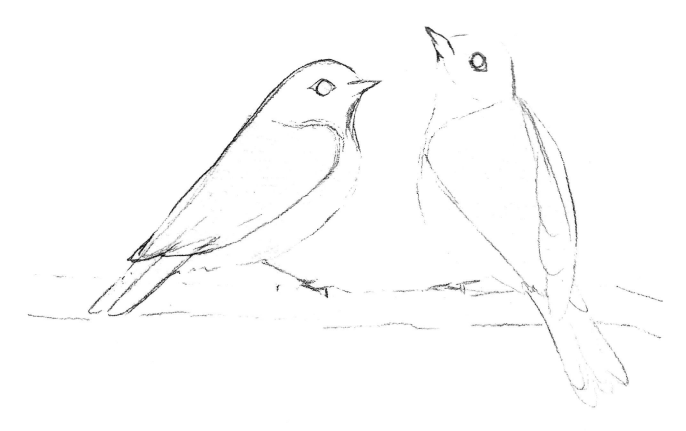

STEP 1

Start this sweet bluebird pair with a simple sketch of the silhouette of the birds, marking important features like the wings and eye placement.

STEP 2

Using the wet-into-wet technique, add color to the bird's bodies, allowing the colors to blend naturally on the wet paper and leaving some white areas for highlights. Allow this step to dry fully before adding the finishing details.

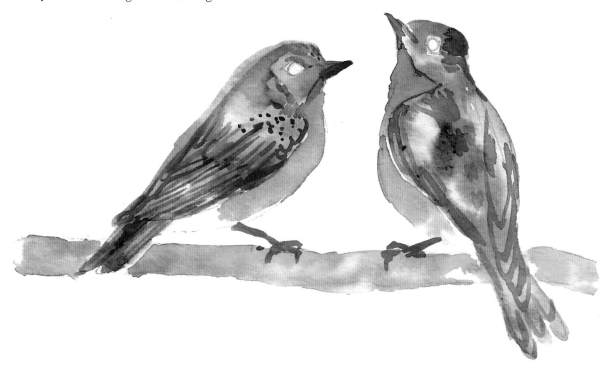

STEP 3

Using a dark neutral color, paint the eyes, leaving a tiny white dot somewhere. This helps make the eye look more realistic. Add final touches of color to the wings, feathers, and branch. Try not to be too heavy-handed with your details; less is often more! You can always add more details, but you can't take them away.

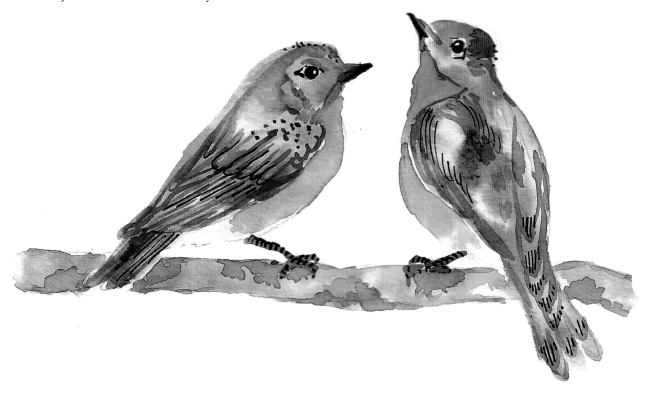

CHICKADEE

Complete the chickadee in much the same way as the bluebirds. Begin with a sketch, and then wet the body of the bird and drop in its colors. Once that is completely dry, add finishing details with a dark neutral color. A fine-point Sharpie® is very helpful for finishing details because you have more control over the stroke than you get with a paintbrush. Use the Sharpie for eyes and tiny dots to give texture to the body.

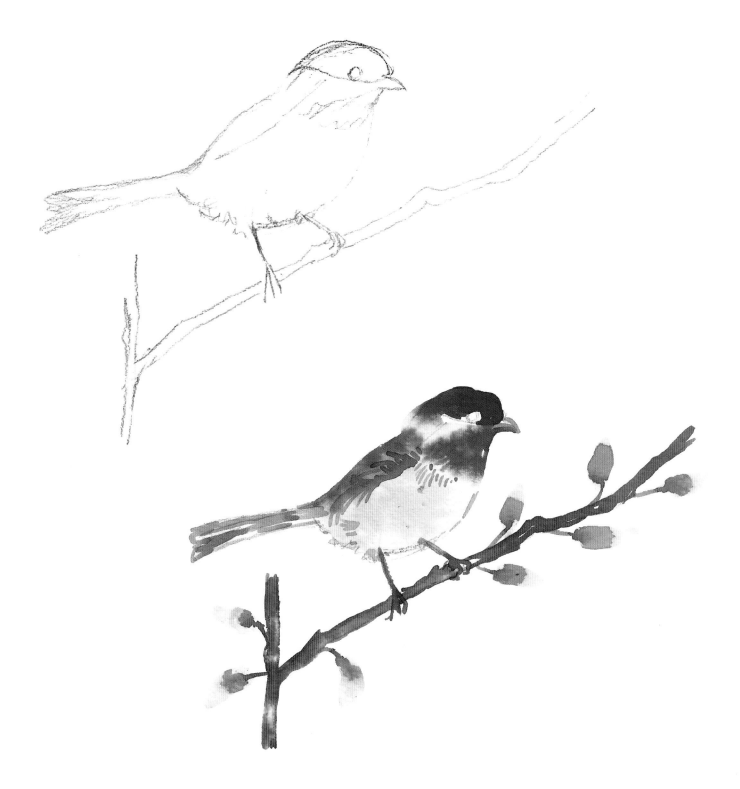

Tip

With birds, it can be a challenge to create a distinct eye area when the feathers surrounding the eye are also black. This is another reason I like to use a black fine-point marker to add details: I get the benefit of two different shades of black. The contrast of the different shades makes them each pop.

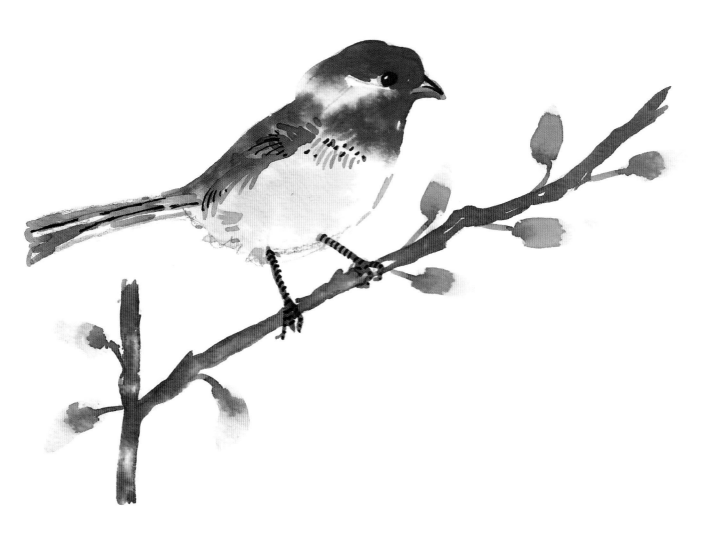

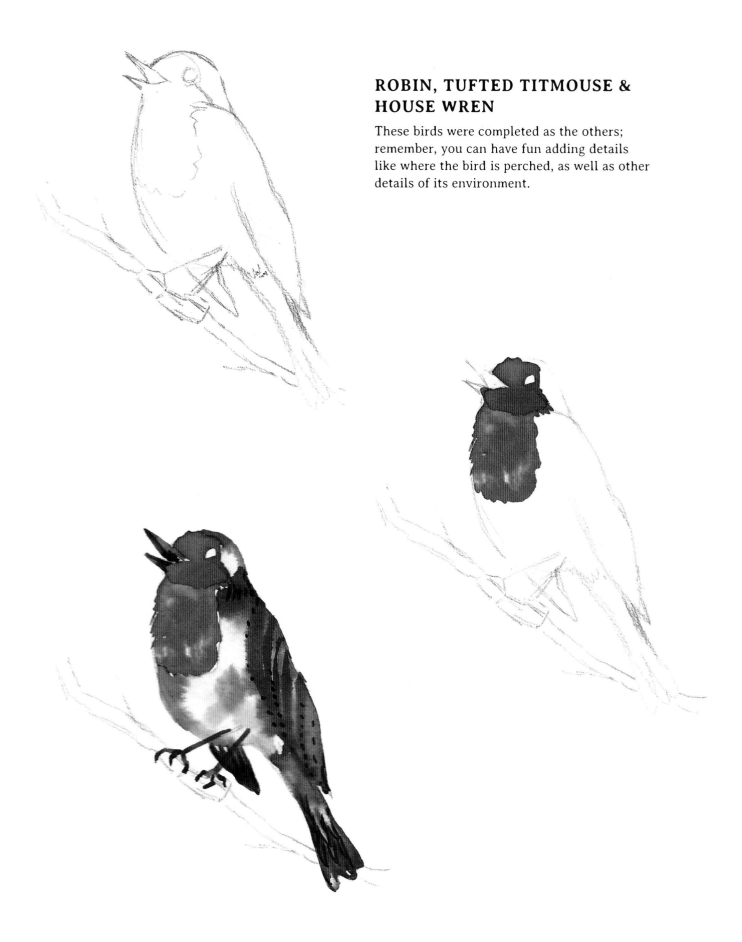

ROBIN, TUFTED TITMOUSE & HOUSE WREN

These birds were completed as the others; remember, you can have fun adding details like where the bird is perched, as well as other details of its environment.

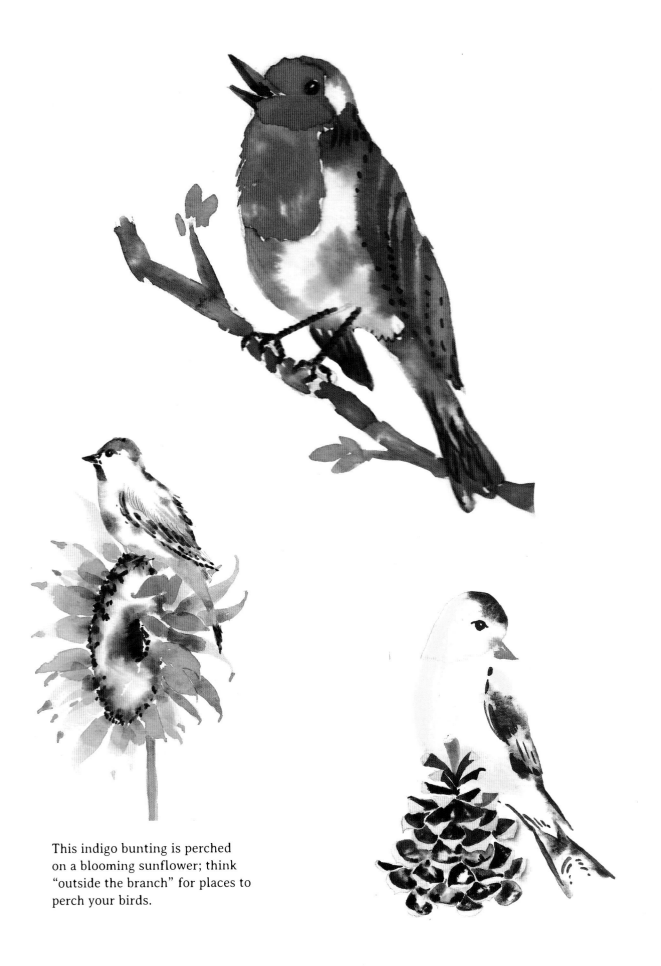

This indigo bunting is perched on a blooming sunflower; think "outside the branch" for places to perch your birds.

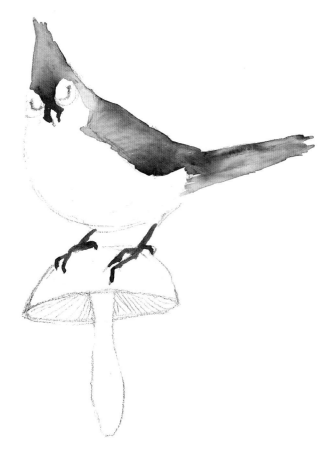

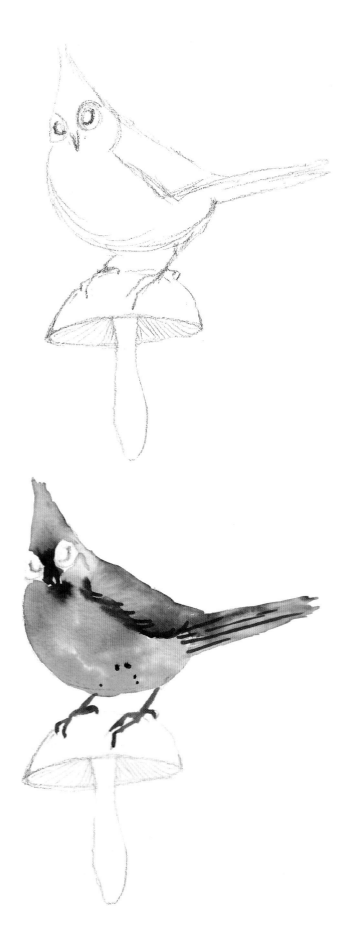

Tip

If you need a visual reference for bird shapes and poses, try a bird book or another picture book. Internet image searches for birds will give you a wealth of different poses from which to choose. See how many different positions you can paint for one type of bird.

Tip

Combining a number of different birds into one composition is a creative challenge and a great way give variety to a scene. This little midsummer illustration from our farm has three different kinds of birds in three different poses.

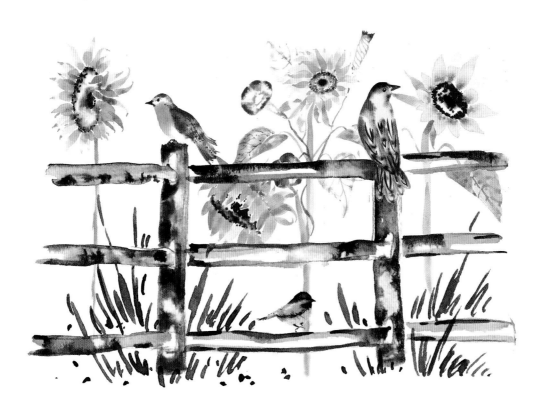

Tip

This little wren is so cute and the wet-into-wet technique is great for giving a soft look to the feathers while also helping to define the patterns in the bird's markings. As your wet area dries, you can continue to add drops of color to create additional patterns in an area. Because the paint dries at different rates, it will produce varying effects.

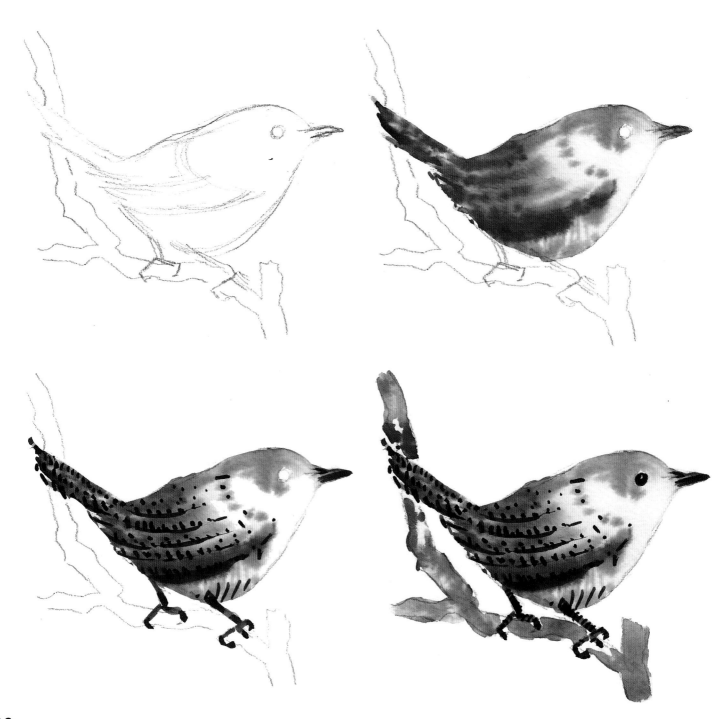

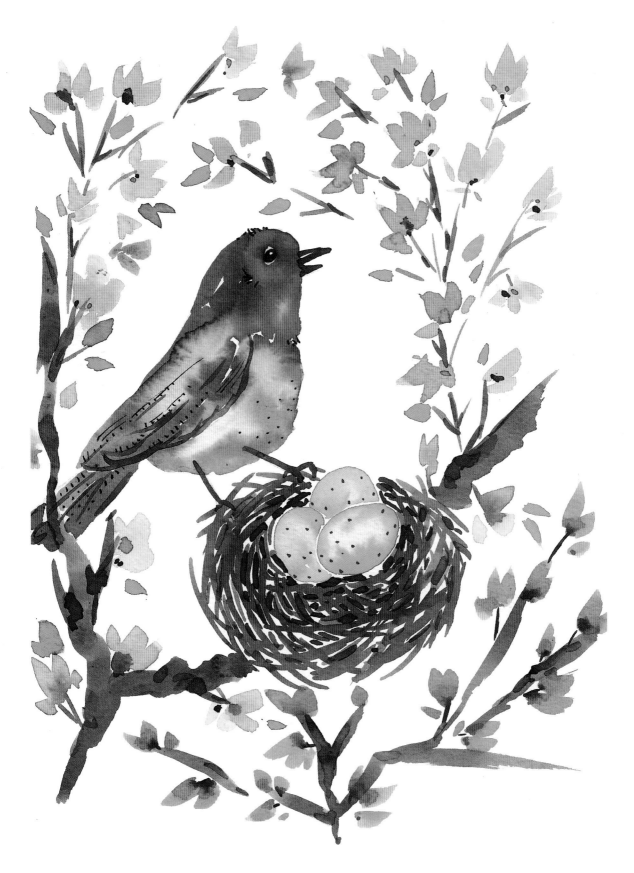

I worked on this project during the spring, and I was inspired by the flowering branches around our farm. This pretty robin awaits its eggs amid the bright forsythia and redbud tree blossoms. Now that you're practiced at painting birds, what environment will your feathered friends live in?

Flora Outside Your Window

One of my very favorite things to paint is the flowers outside my door. I've always dreamt of having beautiful flower gardens, so it's a great thing I married a green thumb! We grow flowers for cutting together as a family; it's our hobby and one of my greatest sources of inspiration.

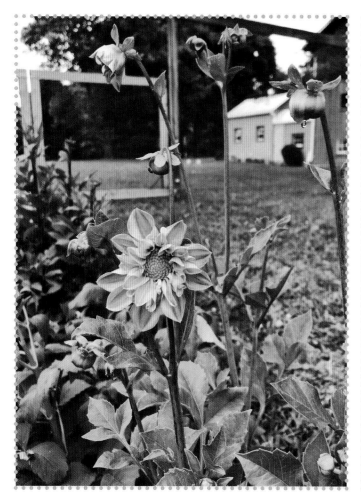 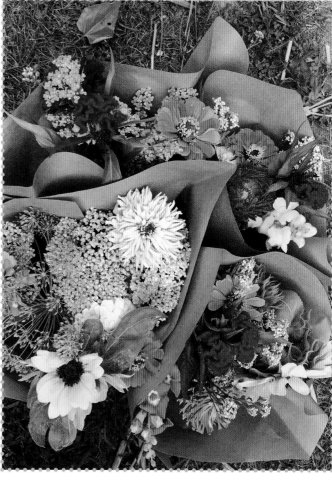

I've written these flower paintings as "recipes," giving you all the ingredients you need to paint them yourself. Refer to the brushstroke instructions on pages 16-17 for more detail on how to execute each brushstroke. Once you get the hang of it, a whole new world awaits and you can flower it up as you desire.

Anemone

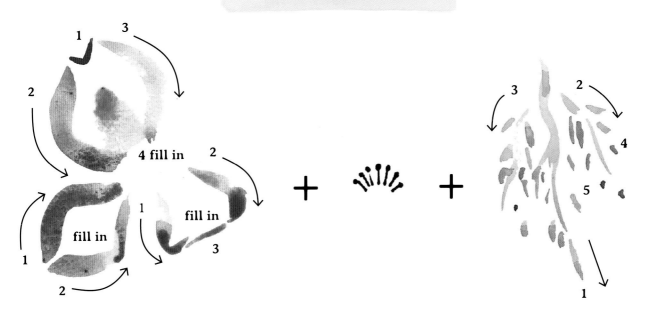

Form the flower head by using outline strokes to create the shapes of the petals; then fill them in.

Create stamens surrounding the dark center with a fine-tip marker, and place a dot at the ends.

Use fine outline strokes to create the feathery foliage.

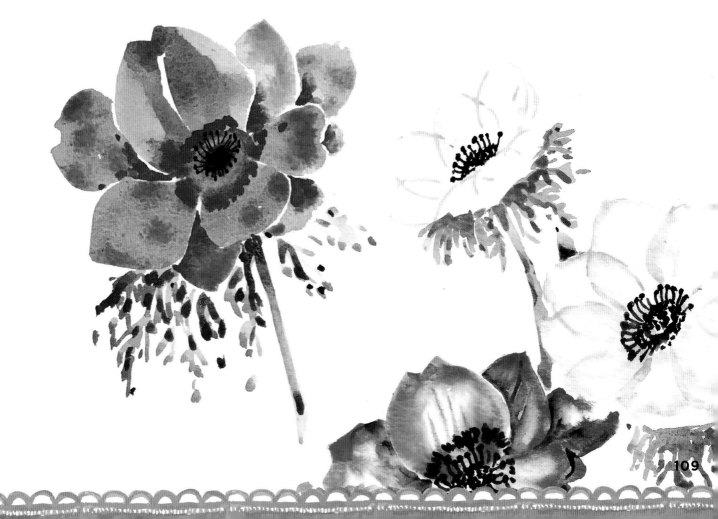

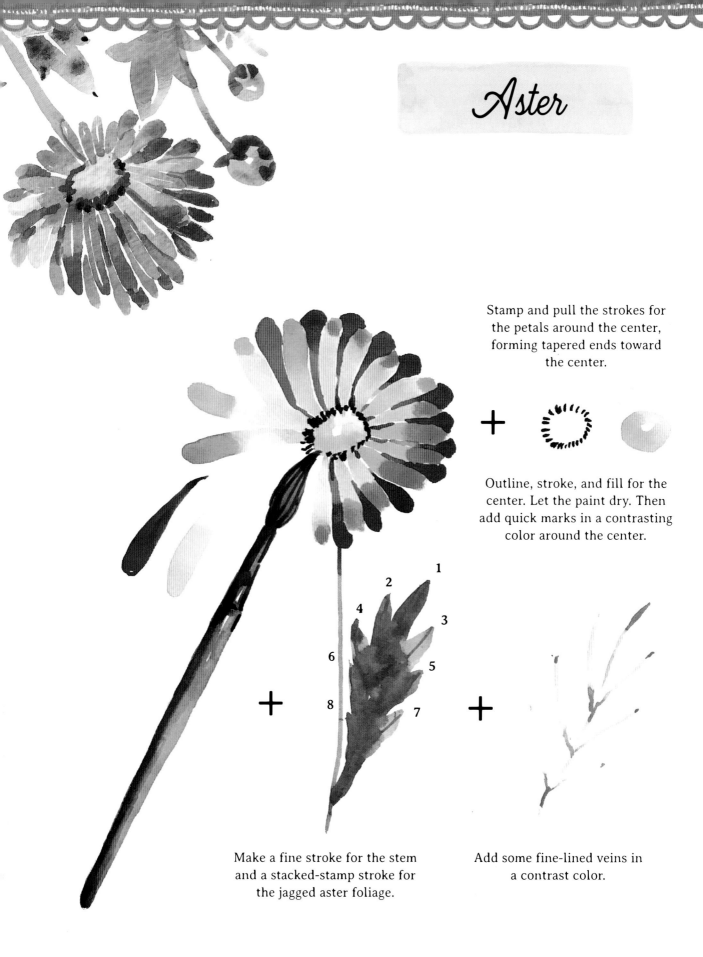

Aster

Stamp and pull the strokes for the petals around the center, forming tapered ends toward the center.

Outline, stroke, and fill for the center. Let the paint dry. Then add quick marks in a contrasting color around the center.

Make a fine stroke for the stem and a stacked-stamp stroke for the jagged aster foliage.

Add some fine-lined veins in a contrast color.

Bee Balm

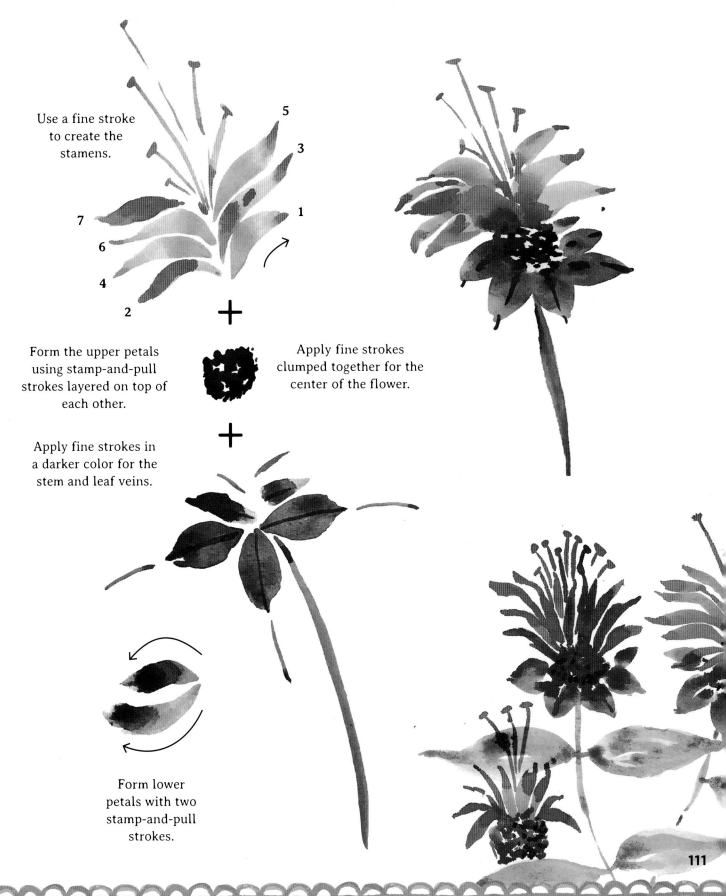

Use a fine stroke to create the stamens.

5
3
1
7
6
4
2

Form the upper petals using stamp-and-pull strokes layered on top of each other.

+

Apply fine strokes clumped together for the center of the flower.

+

Apply fine strokes in a darker color for the stem and leaf veins.

Form lower petals with two stamp-and-pull strokes.

Calendula

 + +

Make long, thick strokes for the petals.

Outline the center in lighter brown, and fill it with darker brown.

Make fine strokes in burgundy around the center.

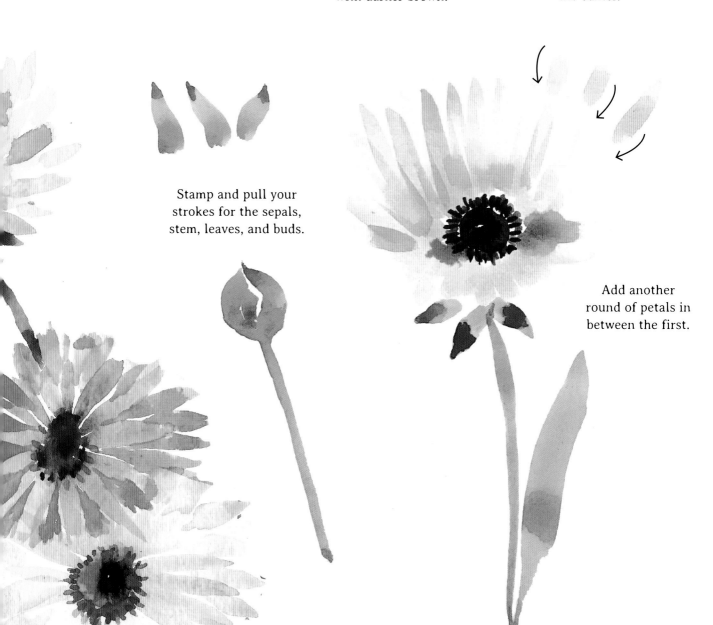

Stamp and pull your strokes for the sepals, stem, leaves, and buds.

Add another round of petals in between the first.

112

Dahlia

Create petals using side-by-side, stamp-and-pull strokes.

Form the center of the flower with stamp-and-pull strokes, angled around the middle.

Alternate the petals around the center. Drop a darker color at the base of the wet petals for contrast.

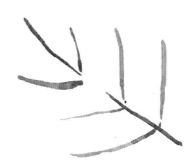

1 2
5
3
7
4
6
8 9

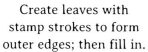

A fine outline stroke is useful for leaf veins.

Create leaves with stamp strokes to form outer edges; then fill in.

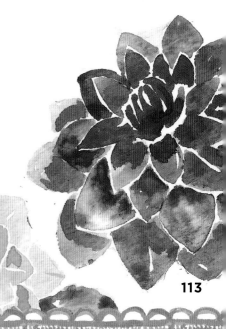

Hydrangea

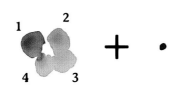

Make a simple flower with four round petals. This is the basic flower unit. Clump a bunch of these together to form the flower head.

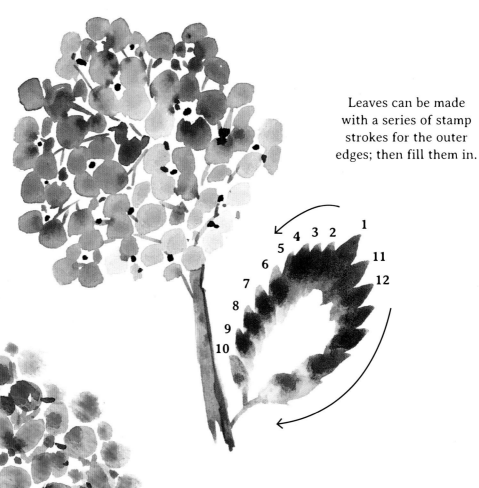

Leaves can be made with a series of stamp strokes for the outer edges; then fill them in.

Hydrangea stems are woody. You can also add little stems in the gaps of the flower head with a fine line.

Sunflower

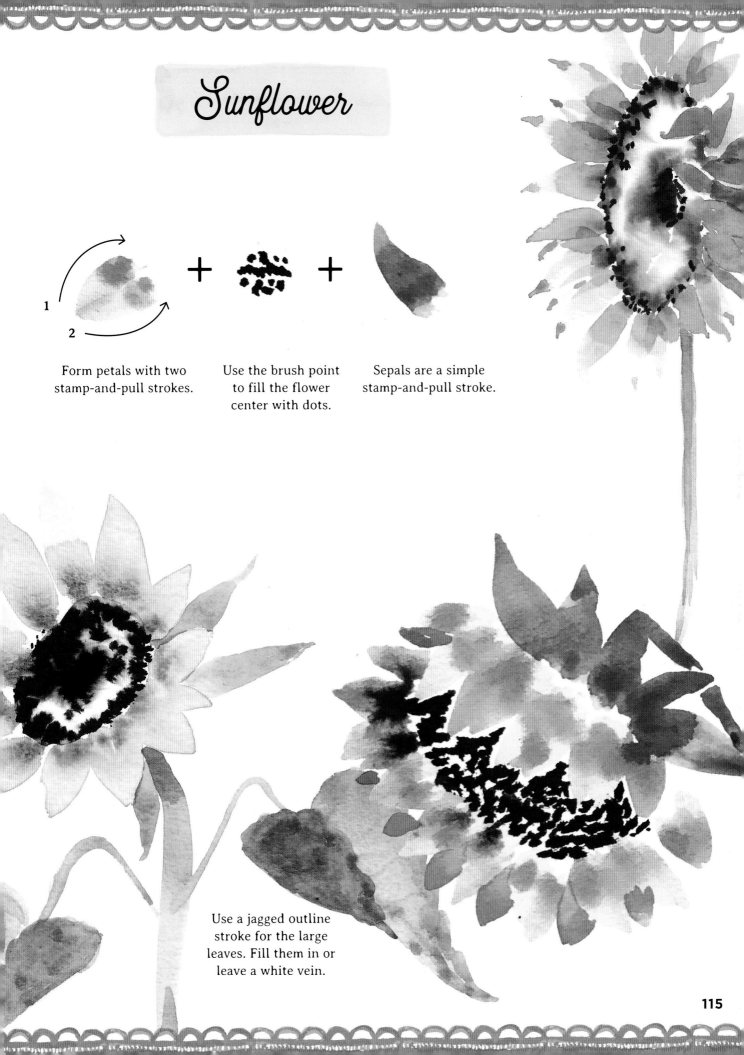

Form petals with two
stamp-and-pull strokes.

Use the brush point
to fill the flower
center with dots.

Sepals are a simple
stamp-and-pull stroke.

Use a jagged outline
stroke for the large
leaves. Fill them in or
leave a white vein.

Flower Jar Craft

Now that you have some experience painting beautiful things around your home, let's use your new skills in some fun crafts! For this project, I've painted a variety of garden flowers, as demonstrated in the "Flora Outside Your Window" project on pages 108–115.

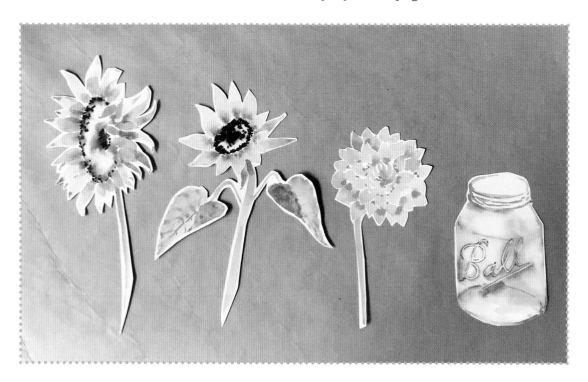

STEP 1

Use scissors to cut out the flowers you've already painted. Be sure to also make a container to put your "bouquet" into; I've done a jar, but you can personalize this and use a special family vase or an antique you love instead.

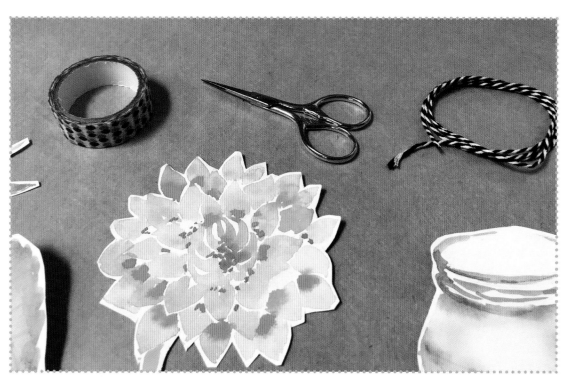

STEP 2

With a craft knife or sharp scissors, cut a line at the front edge of the vase so that you can insert the flower stems through and "put" them in the vase.

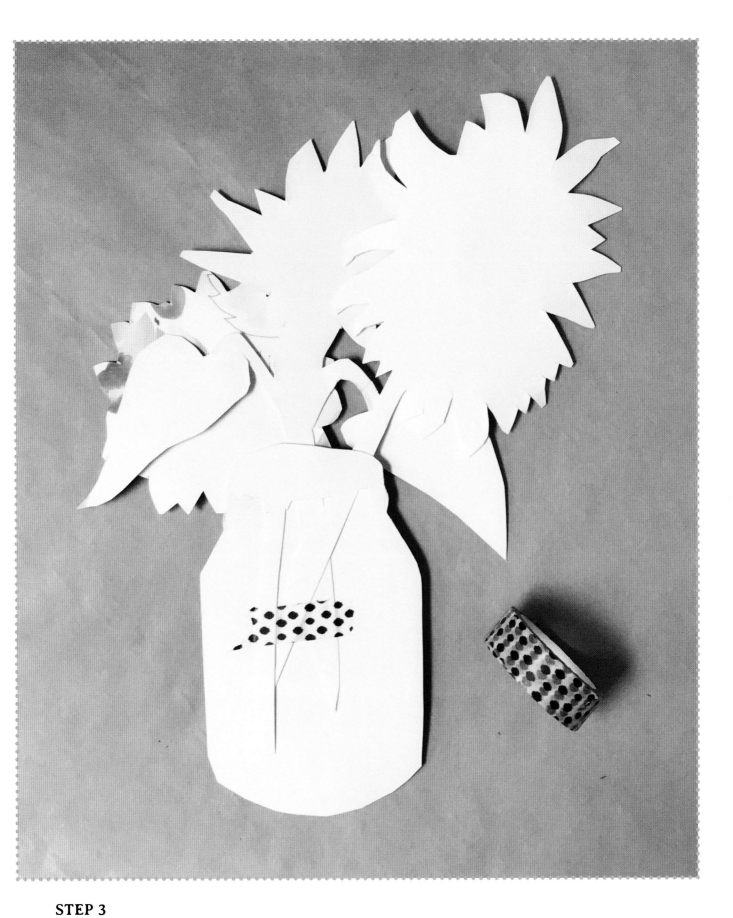

STEP 3

Arrange the flowers in the vase, and then tape them across the back to secure.

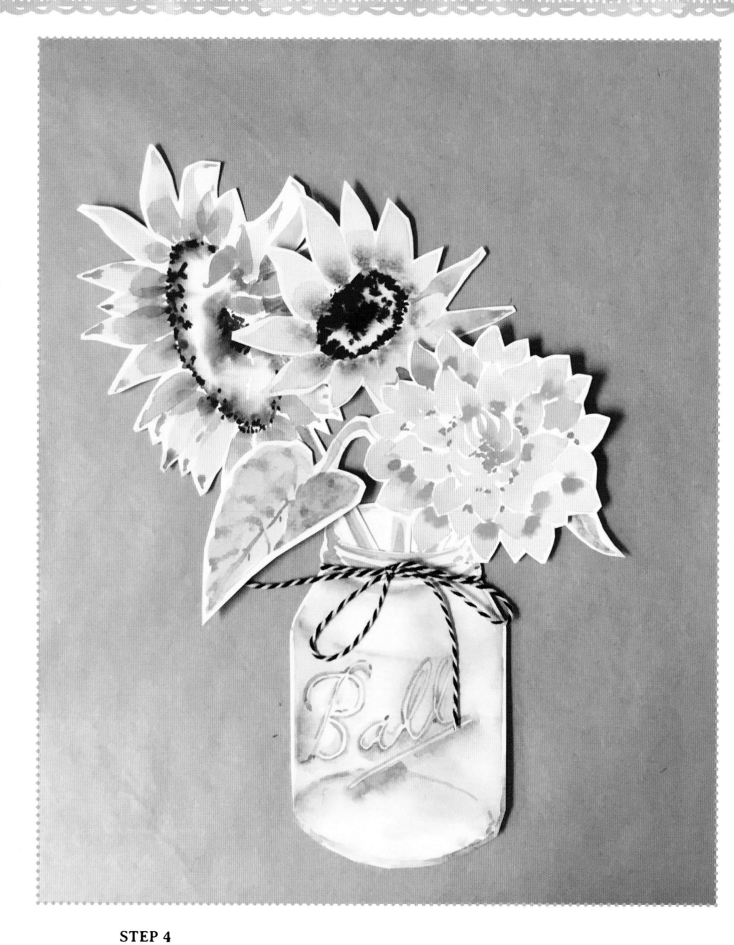

STEP 4

Flip the vase back to the right side and tie a little twine around it for extra appeal!

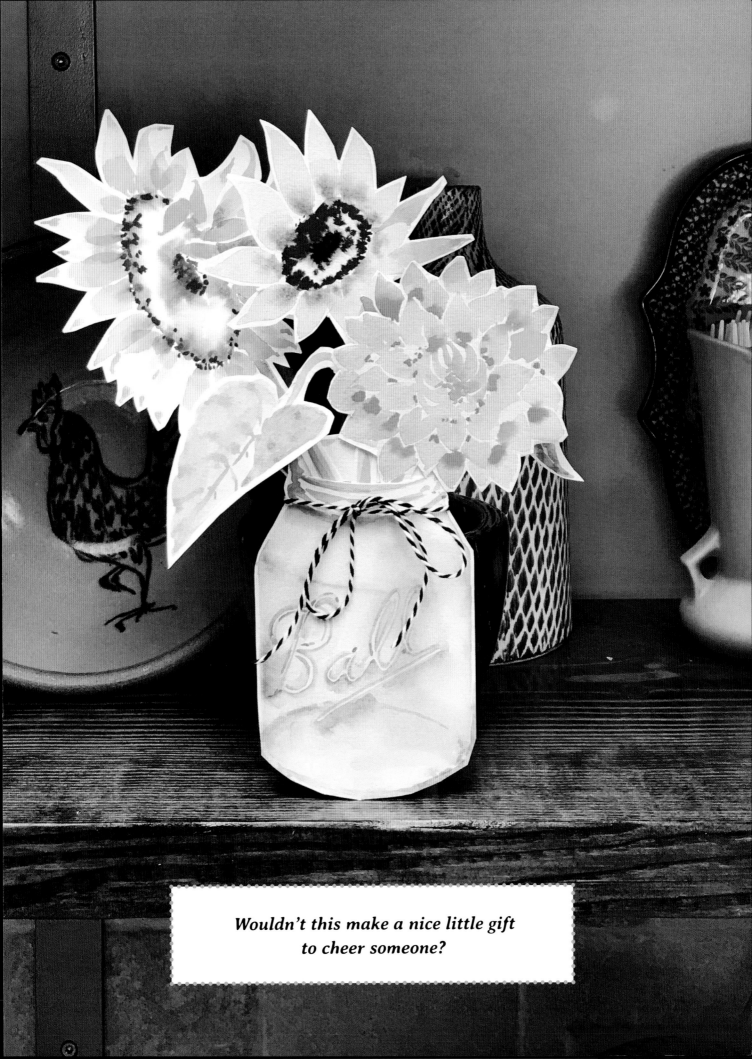

*Wouldn't this make a nice little gift
to cheer someone?*

Festive Seasonal Décor

Once you realize that you can cut out your painted motifs, as in the project on pages 116-119, the possibilities for using your paints to create other decorations are endless. I have had a lot of fun over the years painting and cutting motifs to use in temporary decorations around my home to celebrate the seasons!

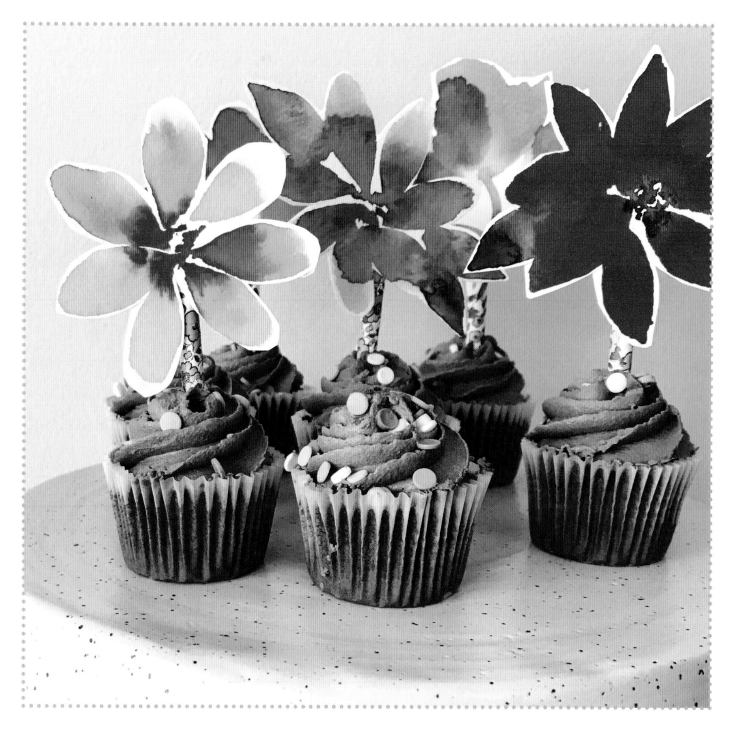

I've made these small cupcake toppers with some flowers that I cut out and attached to decorative paper straws. I think they are pretty cute—just think of the ways you could personalize this!

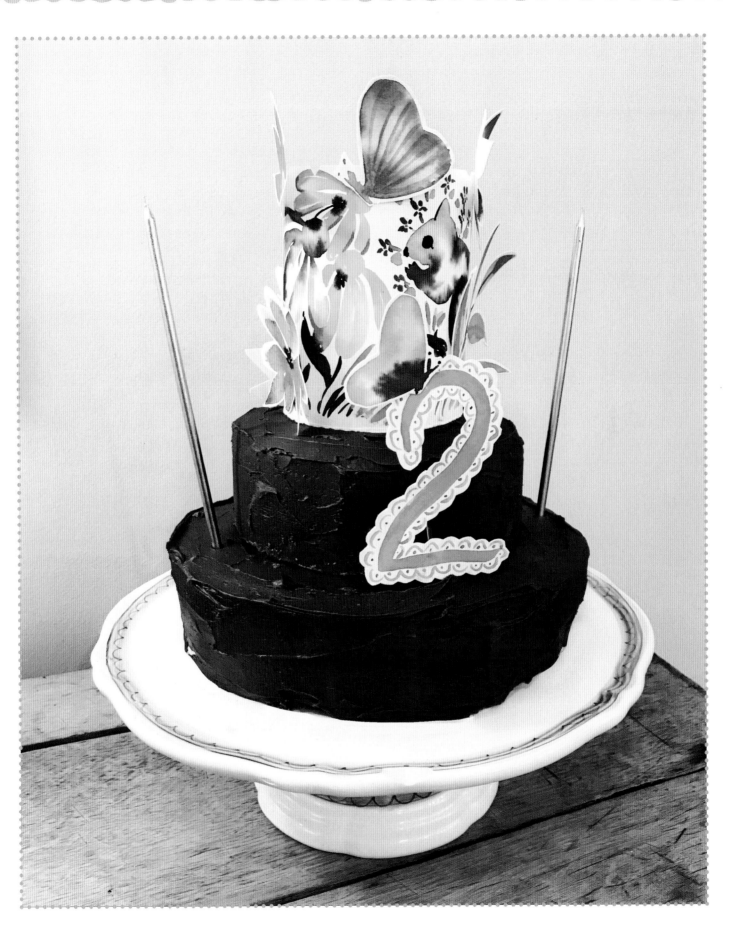

Using a similar idea to the one on page 120, I've painted this cake topper for my child's second birthday. It matches a fall theme since that is when her birthday falls and includes a special painted number as well.

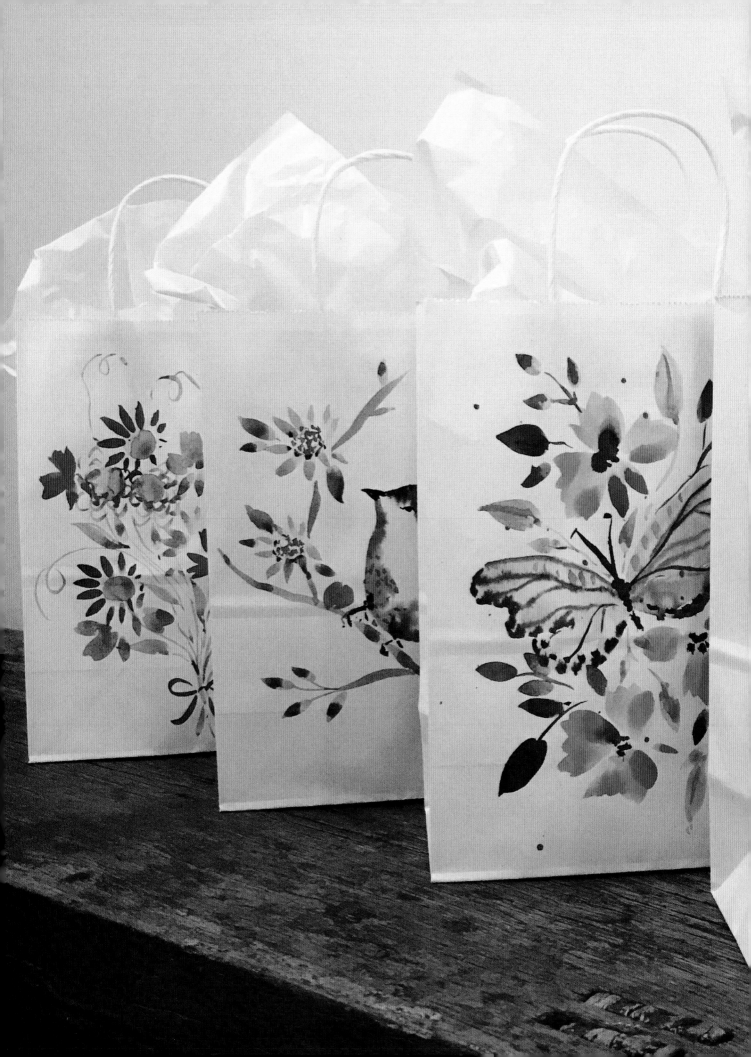

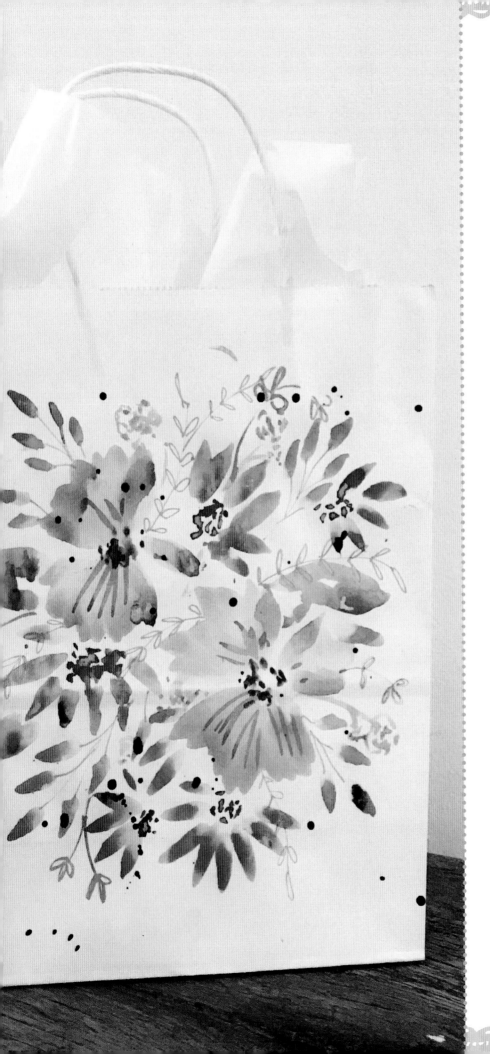

Imagine you are hosting a special party. You could paint many of the decorations yourself, as well as treat bags! These are just plain white paper bags that I've painted for some beautiful treat bags. Any white paper surface is fair game for painted decorations!

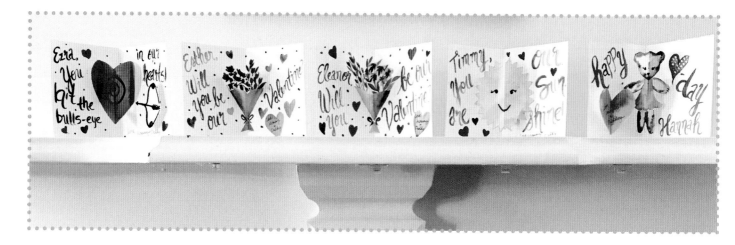

One year for Valentine's Day, I painted pop-up cards for each of my children. They were all personalized to their special characteristics.

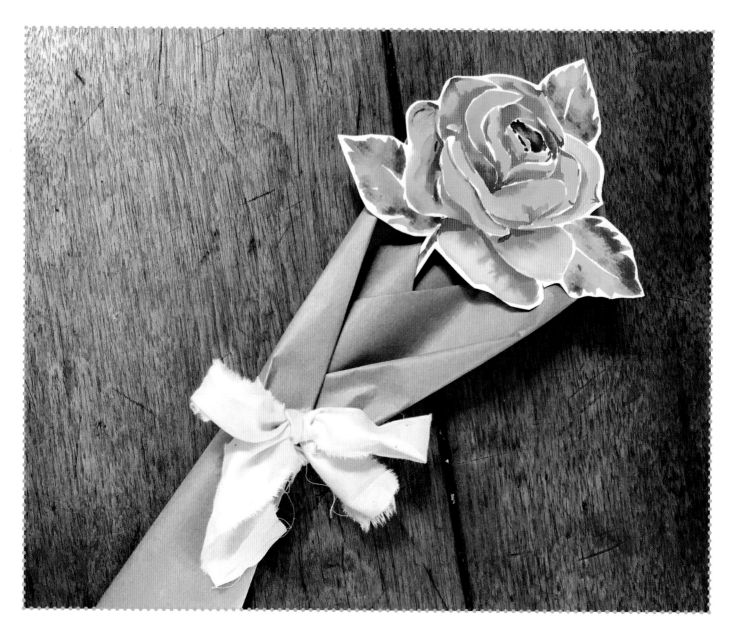

What about surprising your sweetheart with a single painted rose? Wouldn't this be sweet for many occasions?

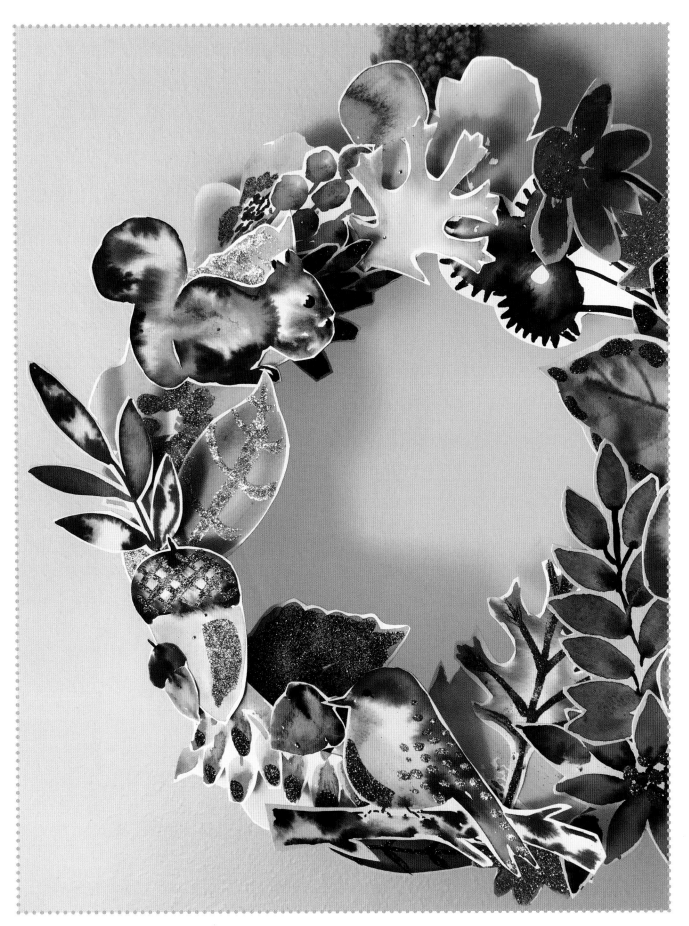

As the seasons turn, I will often paint a wreath to decorate a wall in my home. Using a foam ring and small sewing pins, I simply pin each motif around the ring, overlapping and arranging to my heart's content.

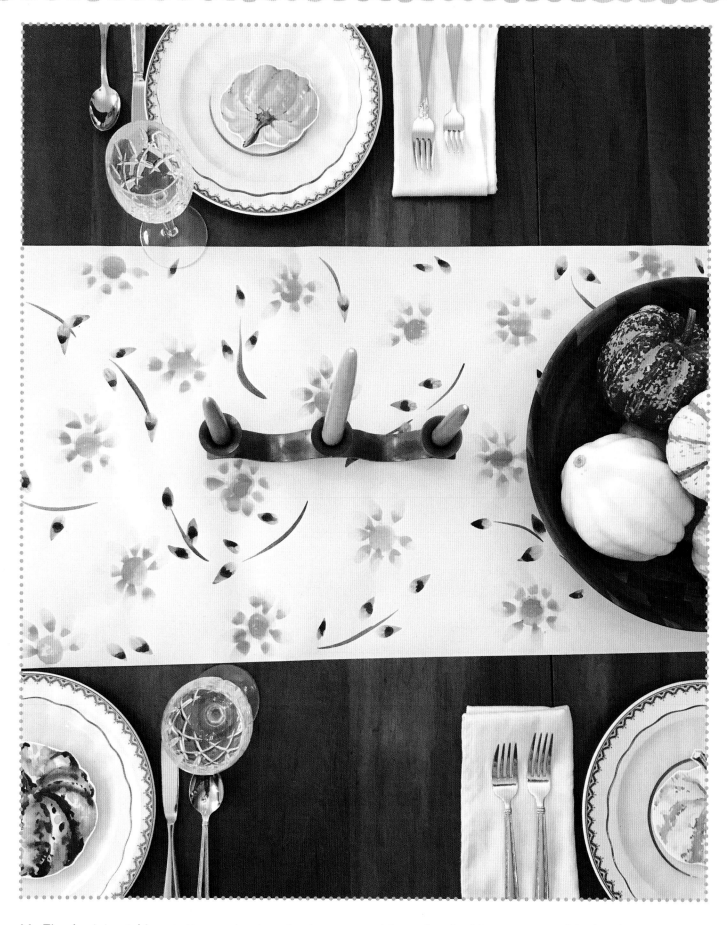

My Thanksgiving table gets the royal watercolor treatment with a painted table runner on white butcher paper and small painted pumpkins at each place setting.

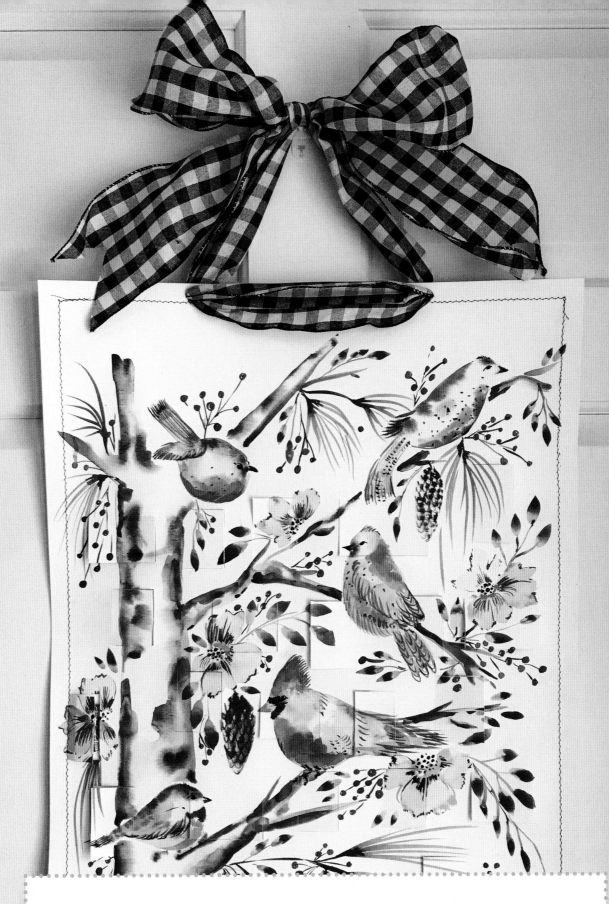

Finally, I enjoy Advent and Christmas by making an Advent calendar. I cut 24 windows out of a large, finished painting, and then hide small chocolates behind each door.

Have some fun with this and come up with your own unique ways to bring your paintings into your home décor!

About the Artist

Bley Hack is a watercolor and oil artist living on an Ohio farm with her husband and six children. Her paintings, designs, and surface patterns are inspired by the fresh florals and vintage charm she spies in her daily life at home, where she paints amid the hustle and bustle at the kitchen table. Bley sells and licenses her work for products in retail markets and enjoys teaching workshops around her hometown.
Learn more at estherbley.com.